IMAGES
of America

NEW EGYPT AND
PLUMSTED TOWNSHIP

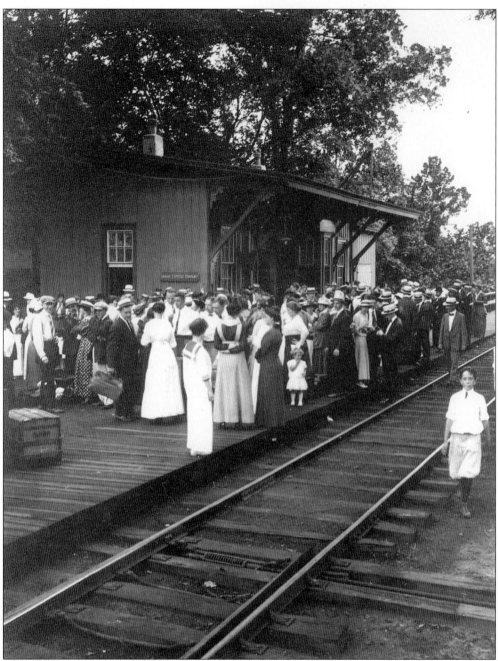

At the beginning of the 20th century and into the decades that followed, New Egypt was a destination: a place to fulfill one's dreams. When vacationers arrived at the station, ready to be met and taken to their hotel, the hiss of the steam engine and the ringing of the bells added to the excitement. They were eager for all the joys a New Egypt summer promised. At the end of the stay, the station was just as crowded and the steam was still hissing, but everything was quieter. The travelers waiting for the train to take them away were a thoughtful crowd, leaving New Egypt behind but taking memories with them that lasted a lifetime. (Courtesy of the New Egypt Historical Society.)

NEW EGYPT AND PLUMSTED TOWNSHIP

IMAGES of America

Arlene S. Bice

Copyright © 2003 by Arlene S. Bice.
ISBN 0-7385-1239-7

First printed in 2003.

Published by Arcadia Publishing,
an imprint of Tempus Publishing Inc.
2A Cumberland Street
Charleston, SC 29401

Printed in Great Britain.

Library of Congress Catalog Card Number: 2003106181

For all general information, contact Arcadia Publishing:
Telephone 843-853-2070
Fax 843-853-0044
E-mail sales@arcadiapublishing.com

For customer service and orders:
Toll-free 1-888-313-2665

Visit us on the Internet at www.arcadiapublishing.com.

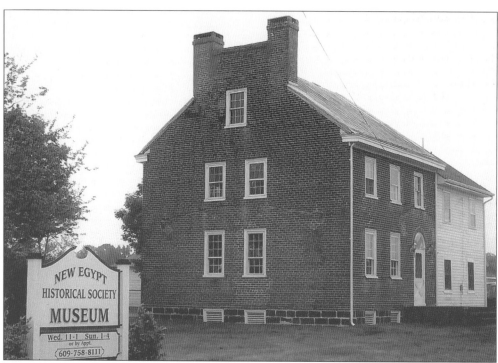

The Singleton Farm had been in the same family for more than 150 years. When the Plumsted Township Board of Education bought the property for a new school, it had no need for the house. Mayor Ronald Dancer and the town council acquired the property and negotiated a plan for the New Egypt Historical Society to lease it for a home and museum. Boy Scout Robert Maier gave $1 as payment. He is now a lifetime member. (Courtesy of Stacy Reed.)

CONTENTS

Acknowledgments		6
Introduction		7
1.	The Resort Years	9
2.	Downtown	27
3.	The Rural Landscape	49
4.	Services	63
5.	Organizations	75
6.	Schools and Churches	83
7.	Sports and Recreation	97
8.	Parades	115
9.	The Railroad	125

ACKNOWLEDGMENTS

Sincere thanks go to the following: the New Egypt Historical Society board members; Carol Reed, New Egypt Historical Society president, who truly extended herself and answered calls and questions day and night; Pat Gale, Sarah Jo Mains, and Fran Ondrushek, who gave up Sundays to help sort photographs; Carolyn Lear, Jim Schroeder, Bob Goff, and Ed Earley for giving up their afternoons to help with identifications and for sharing their photographs and wonderful stories for this book; Bill and Karen Kisner for finding time for me in their busy schedules and for lending photographs from their vast collection; Bob Voseller of the New Egypt Press for allowing me to rummage through his boxes of old photographs; Lisa Cleaver for guiding me; Stacy Reed for being available to help with the project and for promoting New Egypt as it should be; and Arcadia editors Susan Jaggard and Pam O'Neil for their help.

A posthumous thank-you goes to the late Thomas Asson and his son Howard Asson, who in the late 1800s and early 1900s photographed everyone and everything they could in New Egypt and Plumsted Township. The Assons recorded a history that would otherwise have been lost. In the same sense, thanks go to the late John Tuppen, who followed in the Asson footsteps with his photography.

For research and references, I relied on *A History of New Egypt and Plumsted Township*, by Dorothy S. Mount; *Pemberton and Hightstown*, the railroad book by John Brinkmann; and *New Egypt Fire Company: The 100th Anniversary*, by Bart Amburgey. For further reference, I used old *New Egypt Press* newspapers, personal memories, and earlier printed pamphlets and booklets.

*For Bill Brady, who first brought me to New Egypt
and taught me to love it, too.*

INTRODUCTION

New Egypt is located at the centermost spot in New Jersey. The Lahway Indians made a natural trail through this area, laying huge logs across what is now Oakford Lake to continue their trip to the ocean for salt and fish to carry them through the long cold winters.

In 1699, Clement Plumstead of London, England, one of the proprietors of the Eastern Division of New Jersey, was granted 2,700 acres of land that comprises the New Egypt area. Plumsted was a Quaker who never came to America. His son Robert Plumsted never crossed the Atlantic Ocean either, but he did sell the land to an American relative, Clement Plumsted, the three-time mayor of Philadelphia. The land passed over his son William Plumsted and was inherited by grandson Thomas. In 1765, Thomas Plumsted built a mansion, Mount Clement, near Crosswicks Creek, which flows from Oakford Lake down to join the Delaware River. The township was named with the American spelling of Plumsted to honor this family.

The mills at Oakford Lake and Stony Ford Brook, below Willow Lake, drew farmers to Kimmons Mills and Snuff Mill, as the towns were known then. Cowperthwaite Kimmons ran a very successful business with his mill in the early 1700s. He stocked his bins and storage areas to capacity when the harvest was good. When a couple of barren years in far-reaching areas resulted in failed crops, people came to him to buy seed and grain. They referred to this as in biblical times when the people went to Egypt for corn. So the name of Egypt became well known, and the new name stayed. It eventually evolved to New Egypt. As time moved along, so did New Egypt and Plumsted Township.

The 1830s brought the railroad to America, and on February 6, 1868, the grand excursion of the Pemberton & Hightstown brought the railroad to New Egypt. The train left from Camden with 1,000 celebrants on board 22 cars. Snowdrifts slowed the train down a bit, but it proved to be a grand affair.

The development of railroad travel brought New Egypt great prosperity. Natural fertilizer marl beds scattered throughout the area made good soil for growing crops and raising farm animals. It was much easier to transport farm products by rail than by the deeply rutted roads. After the Pennsylvania Railroad stopped the rail line to New Egypt, the Union Transportation Company, a cooperative, was formed and operated the railroad between Pemberton and Hightstown. Milk, cattle, coal, and other products were hauled by freight cars.

In 1895, Edward A.J. Harley brought his family to New Egypt for the summer. While there, he made reservations for the following year and returned with family and friends. This began the explosion of vacationers and altered the face of New Egypt. The people conveniently

arrived by railroad. During the summer months, husbands could even commute to work, reaching Philadelphia within one and a half hours or New York in nearly the same time frame.

When families arrived in the early 20th century, they found 25 hotels and boardinghouses in or around the town. They also found a bank, four general stores, two barbershops, a drugstore, five bakeries and confectionery shops, two jewelry stores, a shoe store, a dentist, three carriage factories and blacksmith shops, 18 basket factories, a cigar factory, a pajama factory, plumbers, lumbermills, livery stables, and excellent telephone service.

For pleasure, they found Oakford Lake for swimming, boating, fishing, and the highlight of the summer, the annual Lake Carnival. Parades, theater, picnics in the fresh country air, and a lack of mosquitoes added to their delight. Baseball games and other sports were plentiful. After the summer season, hunting in the many forests in Plumsted Township was as popular as the winter sports of ice-skating and sledding. Hiking and hunting for American Indian artifacts were interesting pastimes.

As the automobile became more common to the average family and roads were in better condition, people began to drive to the Jersey Shore for holidays. Fishing, hunting, and many of the other activities remained as favorite hobbies for the residents. Also, with the advent of the automobile, racing became a passion. Both auto racing at the New Egypt Speedway and horse racing came into favor. Several horse farms in the area catered to breeding, training, and racing of Standardbreds for harness racing of trotters and pacers.

U-Pick Farms stepped up to the desire of city folk wanting to come out to experience picking their own fresh vegetables and fruits. The charm of rural living retained its place in this geographical centermost spot of New Jersey.

One
THE RESORT YEARS

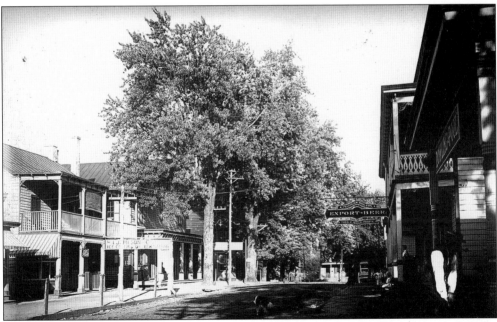

This view of Main Street looks north to the end, where the town divides into North Main Street and merges the two original towns of Newport (Snuff Mill) and Kimmons Mills (Timmons) into New Egypt. The American House, under the ownership of Theodore C. Wills, is on the right. The Jameson ice-cream shop is on the left. (Courtesy of Bill and Karen Kisner.)

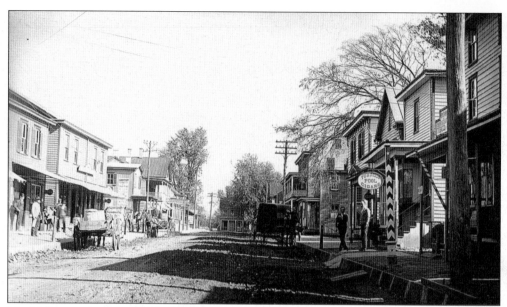

Mr. Mallory started the Oakford Land Company and promised the townspeople that he would pave the roads with brick if they would change the name of the town to Oakford. They voted in the name change, but the Pemberton & Hightstown Railroad refused to change the name on its timetables. The following year, New Egypt was voted back in, but they changed the name of Mill Pond to Oakford Lake. (Courtesy of Bill and Karen Kisner.)

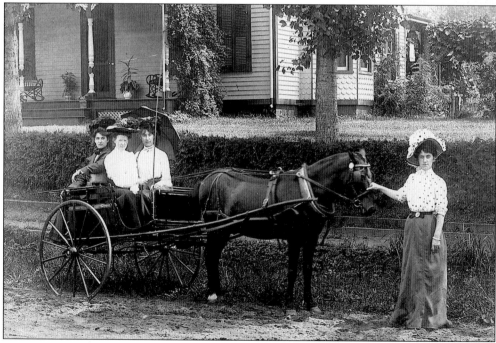

One of the pastimes for vacationers was to go for a drive with a horse and buggy, as these unidentified ladies appear to be doing. Women were less confined in the rural areas of New Jersey and were quite capable to drive themselves about to go shopping, picnicking, or just to enjoy the view. (Courtesy of Bill and Karen Kisner.)

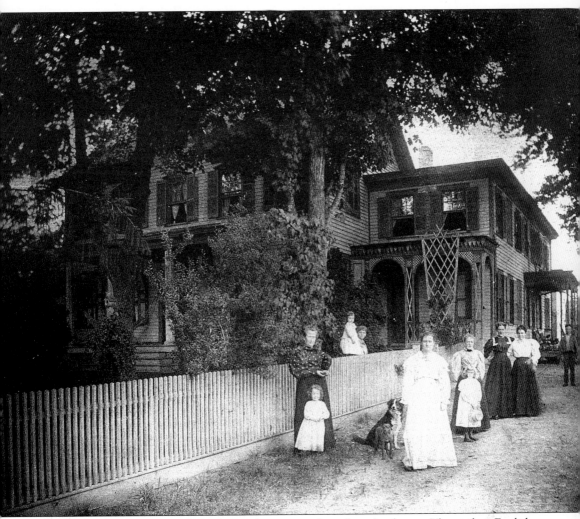

Magnolia Farm was a magnificent home that operated as a boardinghouse. The sunken English gardens had boxwoods alongside the brick sidewalks and a stream running through it. The little boy to the far right is Edward Charles "Sonny" Tantum, whose parents owned Magnolia Farm. His sister Clara is the little girl being held by a guest behind the fence. Sonny is the father of Carolyn Tantum Lear and grandfather of Carol Lear Reed. The story is that Major Montague, a former confederate soldier, came to New Egypt for a quiet place to live. He chose Magnolia Farm. Montague's sister Alice Wallis came to visit with her daughter Bessie. The daughter took the family name as her given name when she married and became Wallis Warfield Simpson. Of course, after the king of England gave up his throne for the love of her, she became the duchess of Windsor. (Courtesy of Carol Reed.)

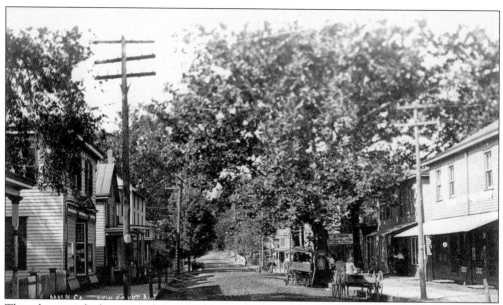

This photograph shows another part of Main Street in New Egypt in 1907. The appearance of a sleepy little town is quite deceptive. The summer season was a bustling time, when the area was swarming with the vacationers from many places. It seems the early bird gets to shop in peace and quiet. Notice the buckboards and wagons along the street. Cars were not common yet. (Courtesy of the New Egypt Historical Society.)

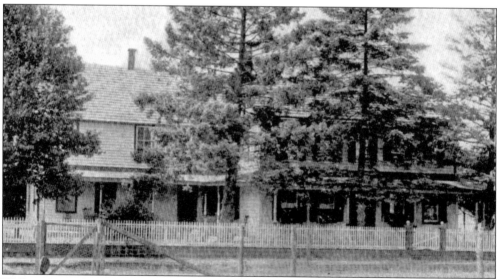

William T. and Nettie L. Brown owned the Shady Grove Farm on Brown Lane in the late 1800s and early 1900s. They ran this sprawling summer boardinghouse with the help of their four children—Lavinia, Orville, Elizabeth, and Martha. The reputation of excellent food kept the house full of visitors at all times. Brown Lane was named for them. Martha, "Mattie," stated that her great-great-grandfather was a personal friend of George Washington. (Courtesy of the New Egypt Historical Society.)

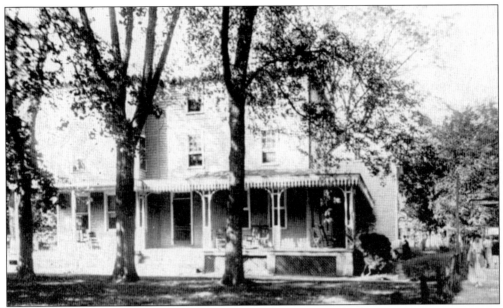

In 1915, Dr. M.A. Morin, owner of the successful Colonial House on North Main Street, bought the Cedarbrook House. The expansion allowed room for a large garden and a tennis court in the back for all the guests to use. They also used the dining room at the Cedarbrook House, as did the guests staying at the Colonial. Dr. George F. Fort owned this property in the 1800s, and Dr. Charles Patterson owned the house and grounds in the late 1700s. (Courtesy of the New Egypt Historical Society.)

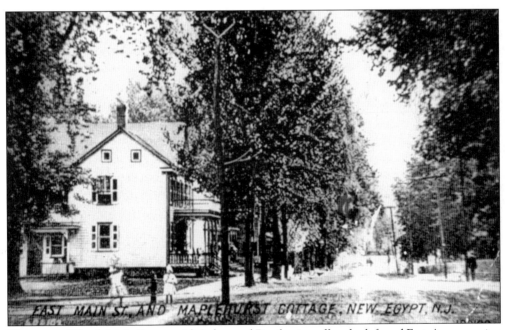

This view of North Main Street, with Lakewood Road going off to the left and Fort Avenue going off to the right, was rarely photographed. Beautiful Maplehurst Cottage is on the left. A horse and buggy is coming down the road from Main Street. (Courtesy of the New Egypt Press.)

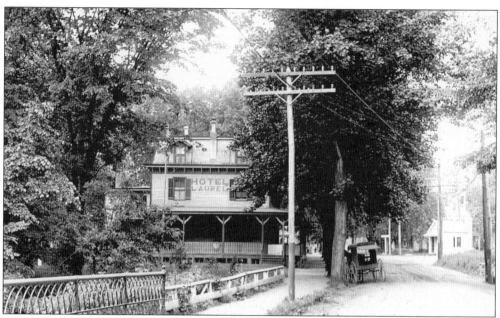

When the Laurel Hotel was bought in 1911 by Charles F. Parker, a former Philadelphia policeman, he made many improvements, including a new garage. The wraparound porches, fine restaurant, well-stocked bar, music in the public parlors, and proximity to the railroad station made for another successful business in town. (Courtesy of the New Egypt Historical Society.)

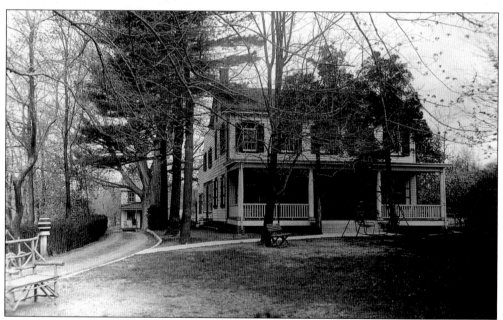

Dr. Louis E. Foulks and his wife, Jessica, purchased this home, Meadowbrook, in 1905. It was part of the original property on which the Snuff Mill (later Lovetts Mill) stood. They opened the house in the summer months to boarders. In time, they remodeled the mill into guest rooms. Their two sons, Stuart and Milton, built the theater on Main Street. (Courtesy of the New Egypt Historic Society.)

Standing on the front porch of the Mill House is Louis Larsen, who came to this country from Germany as a very small child. He learned the barber trade in Newark and went on to become the manager of the famous Prudential Barber Shop. In 1902, he came to Jacobstown to try his hand at traveling the surrounding countryside with a horse and wagon for the Grand Union Tea Company. He took his family to Newark, but his love of this area drew him back again. In 1912, he opened a barbershop on Main Street. The Mill House, located on Main Street, was a popular boardinghouse during the vacation season. Notice the dirt road that curves around it and past the artesian well and continues along Oakford Lake. This road became Lakeview Drive. (Courtesy of the New Egypt Historical Society.)

Morris E. Lamb was the owner of the largest and very popular private boardinghouse, Oakford Lake House. He started out with a general store and expanded his business enterprises by adding a gristmill and a pajama factory to the list. He then developed a tract of land for fine residential homes, started the electric light company, and built the original water plant (in conjunction with George L. Shinn) and the concrete dam. He was also a director of the First National Bank and the Farmers Telephone Company. Lamb grew up in the area and invested all his time and money in New Egypt. (Courtesy of the New Egypt Historical Society.)

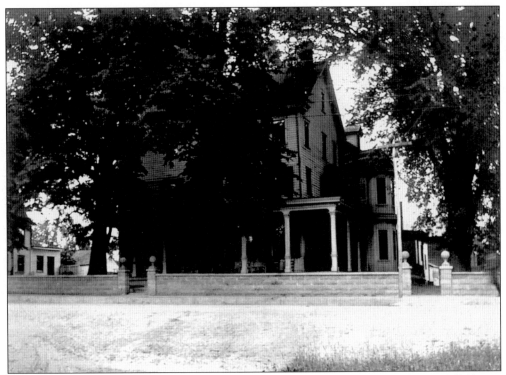

This is another view of the Oakford Lake House in the summer, with the trees in full bloom. Many of the boardinghouses and hotels had year-round guests. Activities did not slow down so much, as the things to do would change with the seasons. (Courtesy of the New Egypt Press.)

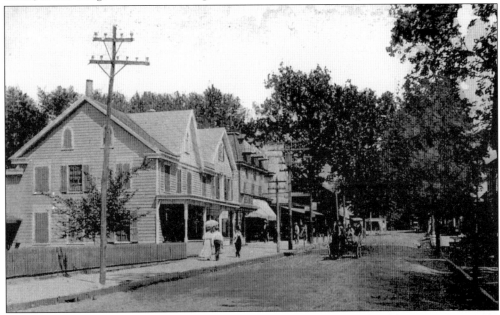

This view of Main Street looks east from the Iron Bridge before the land between Crosswicks Creek and Rush Warwick's building was built up with soil. The street was active with horse-drawn wagons at this time. (Courtesy of the New Egypt Press.)

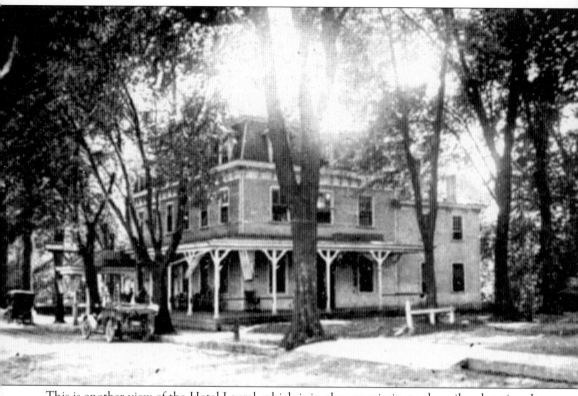

This is another view of the Hotel Laurel, which is in close proximity to the railroad station. It was originally built for the Oakford Land Company headquarters by Gen. E.L. Viele. When the company dissolved, Mr. Mallory, a large shareholder, made it his residence. Charles Thompson bought the building in 1904 for $4,000 and turned it into the Laurel Hotel. The next man to buy the property was John Horner; then, Floyd Rogers bought it from him. Each new owner seemed to make changes or additions to the property that increased its value. The building still stands. (Courtesy of the New Egypt Historical Society.)

This photograph shows a washout near the Laurel Hotel, across from Bright's Farm Equipment on Evergreen Road. The Crosswicks Creek did not overflow often, but when it did, there was damage done. Willow Lake was located off North Main Street, but when the dam gave way, it was never rebuilt and the lake was no more. (Courtesy of Bill and Karen Kisner.)

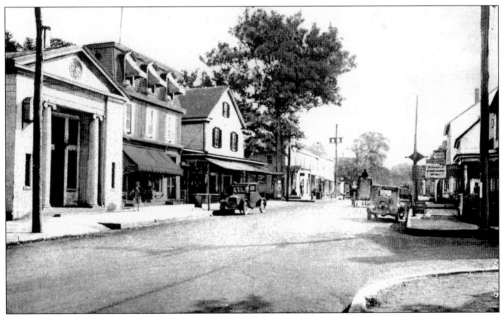

Another Main Street scene shows a few changes, although cars and horse-drawn buggies are both on the roadway. In 1905, a reminder was placed in the paper by Ocean County game warden and Snuff Mill resident Dr. Louis E. Foulks, stating that no dogs could run loose in town from February 1 until October 1. (Courtesy of the New Egypt Historical Society.)

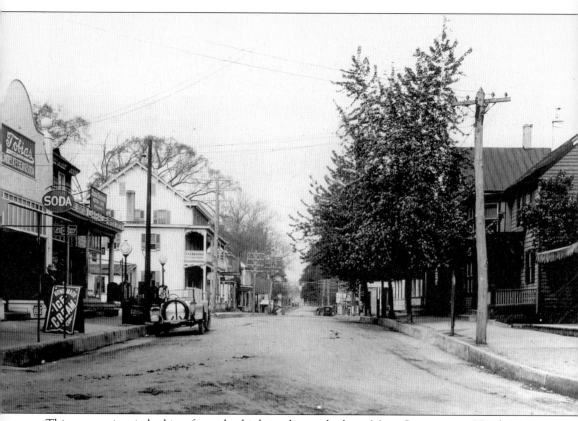

This street view is looking from the kink in the road where Main Street meets North Main Street. On the left, next to the Tobias ice-cream shop, is the Foulks Garage. The two brothers, Stuart D. and Milton, were excellent mechanics and stocked car parts and accessories. They built their own car. New Egypt was once one of the largest makers of carriages and wagons, and now cars and garages were moving in to take over that place. This photograph was taken before the Isis Theatre was built between the garage and the American House a bit farther up the street. (Courtesy of the New Egypt Historical Society.)

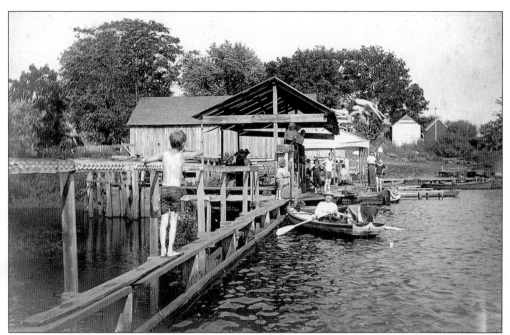

These boys are diving off the roof of the pavilion in Oakford Lake in the early 20th century. Bathing outfits for men and boys were pretty basic, but girls and women were restricted to what was acceptable. The little girl in the photograph is covered from her elbows to just above her ankles. There seems to be lots of adult supervision. This is before the new concrete dam was built. (Courtesy of the New Egypt Historical Society.)

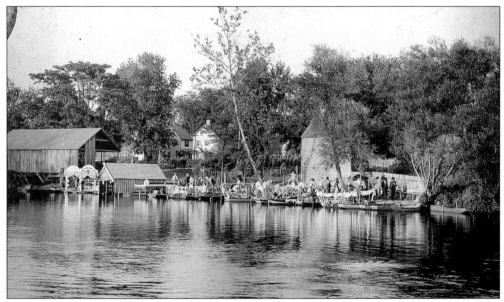

These floats are lined up for the big Lake Carnival. Fires would be lit along the shoreline. Earlier in the day, there were baseball games and band music. After dark, there would be fireworks. On August 16, 1906, the Union Transportation had 2,050 rail passengers heading for the carnival in New Egypt. Three extra trains ran that day. (Courtesy of Bill and Karen Kisner.)

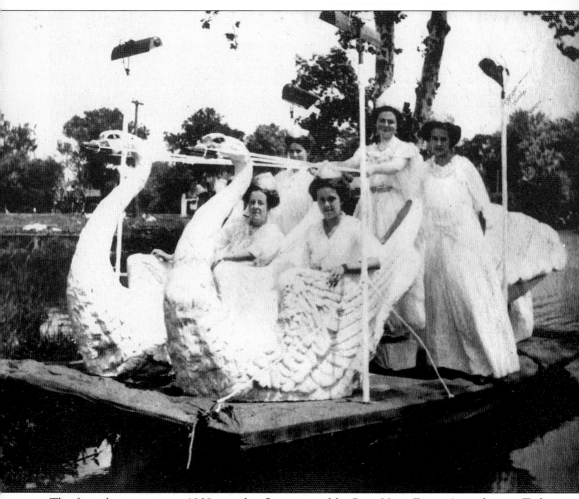

The first-place winner in 1908 was this float entered by Pine View Farm. According to Ted Robbins, whose family owned the Pine View, their guests brought the swans with them. The swans had been in one of the plays at the Palladium Theatre in New York City. The float remained at the Pine View Farm and was refurbished for the bicentennial celebration in 1976. It again had the status of "the Queen's Float." Unfortunately, when the Pine View Farm burned, the float was destroyed. However, the Robbins family donated the crown of the queen to the New Egypt Historical Society, and it remains there on display. (Courtesy of the New Egypt Historical Society.)

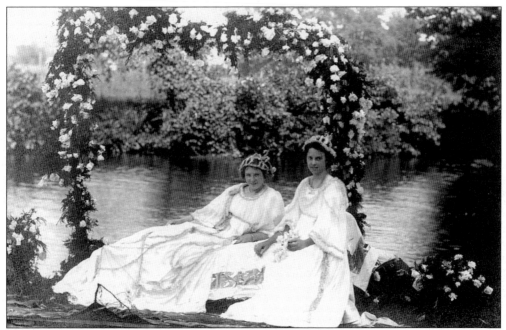

The annual Lake Carnival on Oakford Lake was anticipated with high excitement every summer season. Individuals or groups were allowed to enter. Themes were varied. Japanese lanterns lit up the procession. Three large prizes were awarded, but every entry received some gift. Winner or not, everyone had a wonderful memory forever. (Courtesy of the New Egypt Historical Society.)

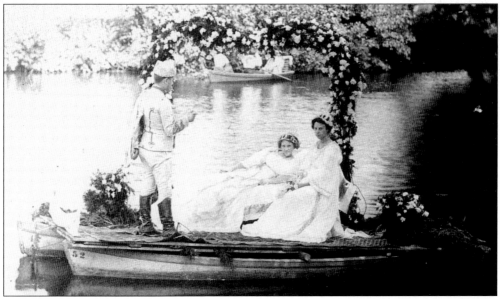

This float entered in the 1908 Lake Carnival seems to have a "sweetheart" theme. Notice the two boats tied together to hold the float. The local businessmen worked together to produce the carnival. They contributed time and prizes. The Union Transportation Company even contributed to the fund. Anyone was encouraged to enter, residents and summer guests. (Courtesy of the New Egypt Historical Society.)

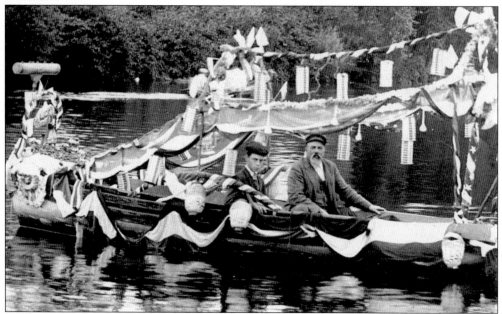

Walter Cottrell and youngster J. Hulme Woodward Jr. entered in the 1910 Lake Carnival. They have gaily adorned their float with many Japanese lanterns and decorations. For certain, there must be a bucket of water hidden in the boat in case of fire from the lanterns. Cottrell lived on Main Street and owned a naptha-propelled launch, with which he provided a round trip to "Wide Ocean" for a nickel. (Courtesy of the New Egypt Historical Society.)

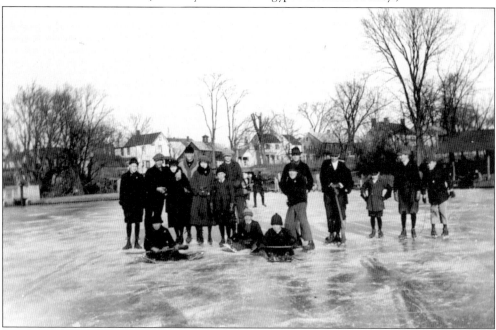

Winter sports were thoroughly enjoyed on Oakford Lake once the lake froze over, as it did here in the 1920s. Standing on the ice are, from left to right, unidentified, Harry Moore, Stella Bayliss, unidentified, Hannah Estel, Dick Sparks, Howard Asson, Norman Irons, and ? Green. Herbert Johnson is on the sled. (Courtesy of the New Egypt Historical Society.)

Brazillia (Juber) Harker moved his boat dock up to the edge of his property on Oakford Lake. He called it Harker's Grove and started a whole new recreation area. First he built a dance hall, pavilion style, with permanent wood sides that went halfway up and pull-up flaps for the rest. Orchestras came from as far away as Philadelphia until the New Egypt musicians took over that spot. Then he added a dining hall, built in the same style but overlooking the lake. He built a carousel and other summertime fun booths. Finally, he purchased the land next to his grove and built a little trestle bridge to reach it. Between 1905 and 1915, Harker's Grove was a destination for many fun-filled days and nights. (Courtesy of the New Egypt Historical Society.)

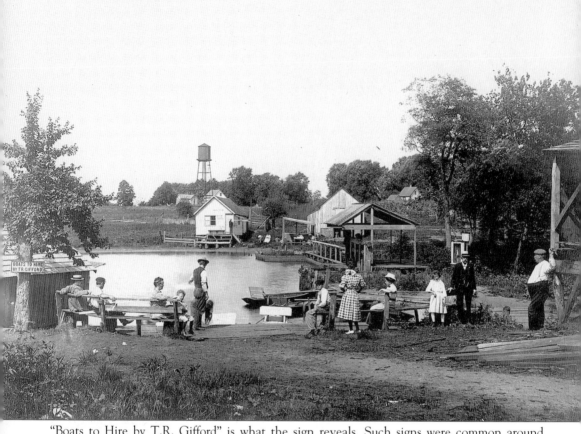

"Boats to Hire by T.R. Gifford" is what the sign reveals. Such signs were common around Oakford Lake. There were many boat docks in different locations that offered rides or rental and a variety of boats to choose from. Swimming off the boat docks was also allowed. In 1907, William Cowperthwait and Frank Cowdrick were out fishing for the afternoon. They caught 12 pike. The largest on the string was a 4-pound 10-ounce fish that was 26 inches long. Much activity surrounded the lake. People gravitated to it, if only for casual conversation or to share a bit of picnic lunch. (Courtesy of Bill and Karen Kisner.)

Two
DOWNTOWN

This is an early location on Main Street for the New Egypt Press, which has been a part of New Egypt and the surrounding area since 1899, when the two Moore brothers created the *Advertiser* (later the *New Egypt Press*). The New Egypt Press also published the *New Jersey School News*, the *American Family Herald*, and the *Parcel Post Journal*, and printed materials for the Union Transportation Company. It still keeps everyone up on the latest news under the editorship of Bob Voseller. (Courtesy of the New Egypt Press.)

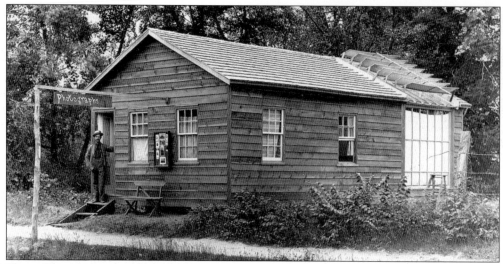

This is Thomas Asson at his original photography studio. Summer vacationers kept him so busy in the summer months that he later expanded his studio to double the size. He left a legacy behind with a multitude of photographs recording life in New Egypt in the late 1800s and early 1900s. He brought his family to live in the Asson homestead on what is now Fort Avenue. His son Howard followed in his steps with his love for photography. (Courtesy of the New Egypt Historic Society.)

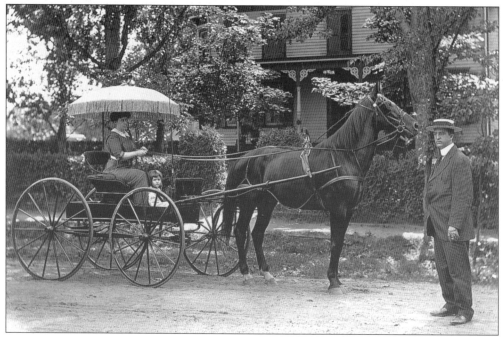

It appears that this unidentified family in a surrey with the fringe on top is stopping at the house of Dr. Howard Allen. Hopefully, this was a social call, not a medical one. Allen was born in 1867 in Clarksburg, New Jersey. He apprenticed with Dr. McKinsey of Perrineville and attended medical school in Baltimore, Maryland. He married Rachel Bean and bought this property in 1889. In a few months, his practice was more than sufficient. (Courtesy of Bill and Karen Kisner.)

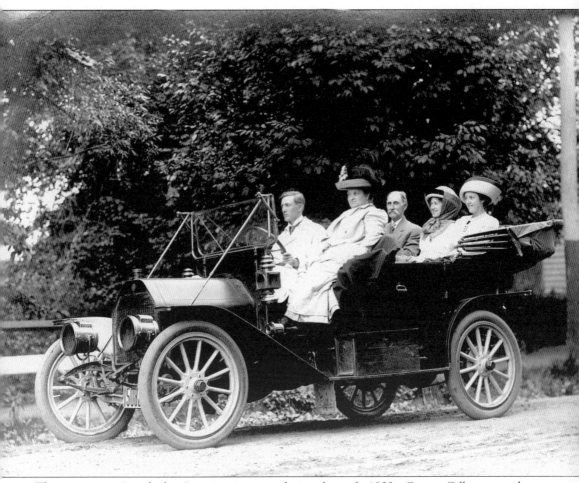

There were two "car for hire" services in town during the early 1900s. George Gilbert owned a five-passenger car that he chauffeured at most hours of the day or night, "at a rate within almost anyone's reach." Gilbert was born in Chesterfield, New Jersey, in 1883. He earned a reputation as a very responsible, congenial young man. Fred S. Chamberlain also owned a five-passenger vehicle for hire. He was born in Camden, New Jersey, in 1892 of an old New Egypt family. He worked for George Halpin's garage until he secured a car for his own business. His reputation was equally as fine as that of Gilbert's. This photograph, taken on Railroad Avenue, could be either of the enterprising young men chauffeuring vacationers on a tour of the area. Records tell us that both individuals did well in business. (Courtesy of Bill and Karen Kisner.)

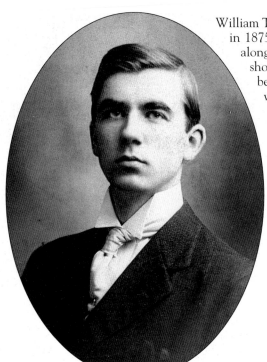

William T. Nash came to New Egypt as an 11-year-old in 1875. He learned to be a cobbler from working alongside his father. In 1888, he opened his own shoe store on Main Street. Soon, he had the best-stocked store and largest variety of shoes within a 15-mile radius. He also became president of the New Egypt Fire Company and leader of the cornet band. (Courtesy of the New Egypt Press.)

William C. Van Horn was one of the men who gathered at Hope Hardware in 1901 to organize a fire company. When the firehouse was built, Van Horn took a team of horses to Lakewood to pick up the first fire truck. He served as an officer for 31 years and many years as chief. He built a large boathouse on the lake next to Lamb's Grove. He was the Plumsted tax collector from 1909 until 1935. (Courtesy of the New Egypt Historical Society.)

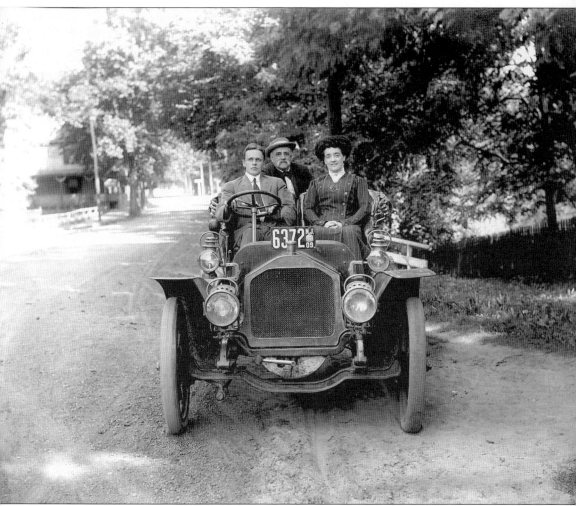

As you see on this license plate, this photograph is from 1909. Cars were beginning to dot the streets. From the background, it seems this one is driving from the Laurel Hotel. Garages and gas pumps were also appearing on Main Street, where George Halpin's original fireproof garage held 10 cars. Within two years, he enlarged the garage to hold 30 cars. He offered short- or long-term storage, maintenance, auto supplies, cars for hire, and roadside repairs. Halpin is on record as having the Ford agency, and he sold at least 60 of them in town by 1915. Before 1910, he built a car by himself. He held a patent on a stub cutter, which cuts two rows at one time. Halpin created a snowplow that he graciously used to plow a road to make way for a funeral in Jacobs. (Courtesy of Bill and Karen Kisner.)

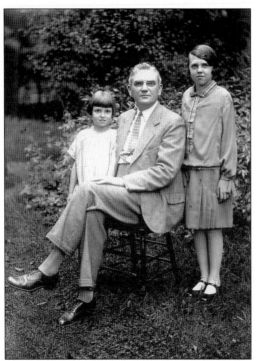

This photograph shows Addison U. Moore with his daughters Treva (left) and Myrtle. He started a local newspaper with his brother Walter Clement Moore. The paper gradually became the *New Egypt Press*, and he became sole owner. He continued as the editor for 53 years. Myrtle followed in her father's footsteps and became editor. She carried on the newspaper business after her father's death. (Courtesy of the New Egypt Historical Society.)

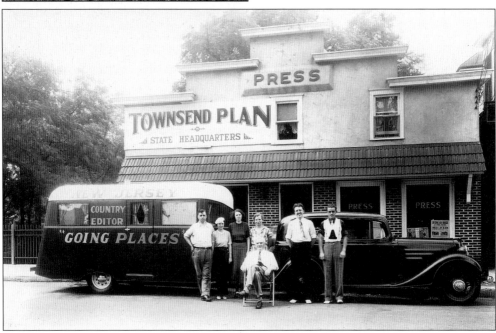

In 1936, Addison Moore (seated) went on the road and talked to every governor in the capital of each of the 48 states. It took him 10 months and three days. His subject was the Townsend Plan. Dr. Francis E. Townsend believed that each person over 60 years of age should retire and receive $200 from the government, which they would be required to spend within 30 days. Pres. Franklin Delano Roosevelt signed a Social Security bill soon after this period. (Courtesy of the New Egypt Historic Society.)

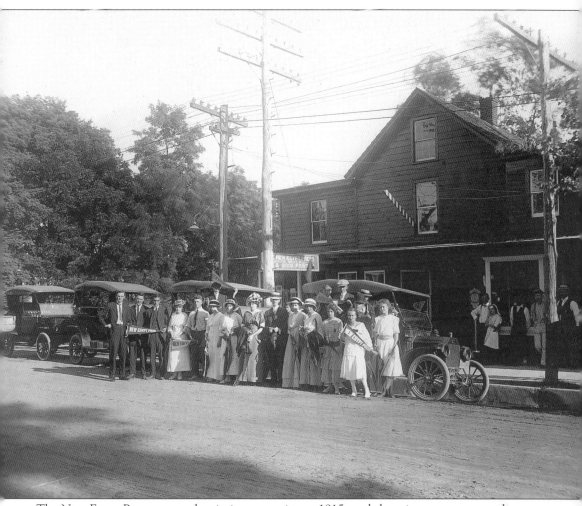

The New Egypt Press ran a subscription campaign c. 1915, and the winners were treated to a trip to Asbury Park. It was an exciting occasion to travel all the way to Asbury Park. A few winners are sporting New Egypt Press banners. For several winners, this was their very first ride in an automobile. This photograph was taken in front of the press building on Main Street. From left to right are the following: (front row) Addison U. Moore, Percy Horner, Fred Chamberlain, Eva Moore, Edward Tantum, Edith Compton, Amalia Ivins, Helen Moore, Walter Clement Moore (editor), Laura Compton, Edna Morin, Clara Tantum, Doris Sager, and Edna Carr; (back row) Guy Davis, Russell Sager, and Clifford South. Standing in the background are, from left to right, Charles W. Hopkins, Helen Sager, and Louis Larsen (the barber from upstairs). (Courtesy of Bill and Karen Kisner.)

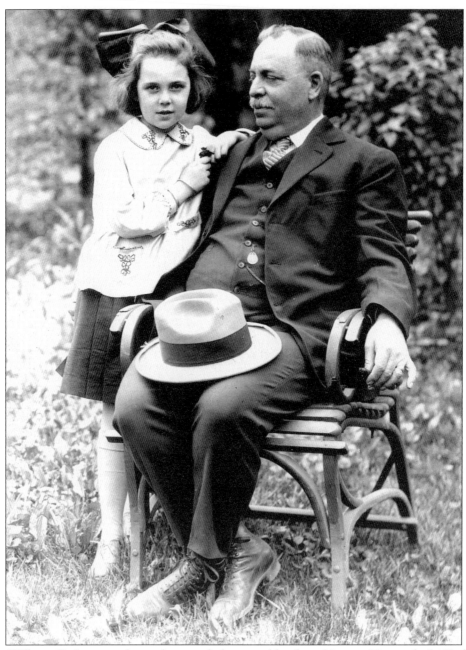

Dr. William C. Jones is shown here with his granddaughter Vivian. His uncle J. Harley Compton invited him to New Egypt to learn the pharmacy business. At that time, the druggist was also expected to attend to burns, cuts, splinters, and any other emergencies. A keen businessman, Jones eventually bought the pharmacy from his uncle. In 1884, he developed a rheumatic remedy, Jones' Break-Up. By 1892, he adopted a trademark for it. The remedy became so in demand from druggists all over the country that by 1913 it was necessary to incorporate and sell stock. He also offered Jones' Little Liver Pills, Cold Tablets, Worm Lozenges, and Syrup White Pine and Tar. In 1917, his only son, Harley, died during the flu epidemic. (Courtesy of the New Egypt Historic Society.)

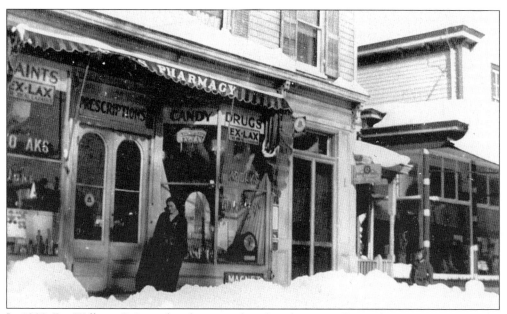

In 1902, Dr. William C. Jones lived upstairs from his pharmacy. For nighttime emergencies, he installed a tube with a mouthpiece similar to a telephone next to the side door of the drugstore. The other end was at his bedside. One needed only to blow into the mouthpiece and state the problem, and Jones would come down immediately. The pharmacy was also the only building in town with indoor plumbing. (Courtesy of the New Egypt Historic Society.)

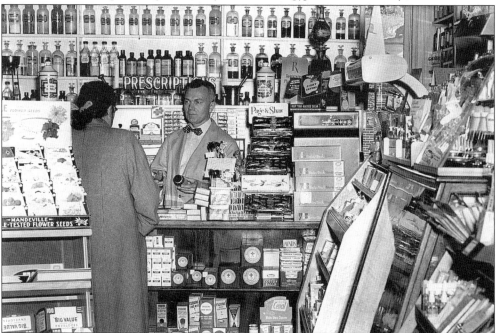

In later years, Dr. Otto Hartman purchased the former Jones' Pharmacy. Hartman made many changes to the building by adding red brick to the exterior and by upgrading the interior to make it modern. However, the apothecary jars lined up along the wall still gave that comfortable feeling of the old-time drugstore. (Courtesy of Bill and Karen Kisner.)

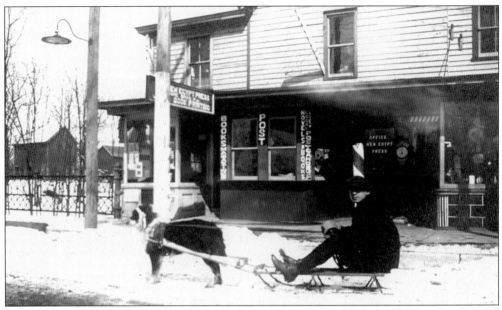

This dog looks like he has been well trained. Another well-trained dog, a German shepherd named June, belonged to Carrie Chafey in the 1930s. June would trot down from her home near the water tower and go to Warwick's to pick up the newspaper every day. One day, June came home with ham in her mouth instead of the newspaper. Rush Warwick did without lunch that day, and that was the end of June's career as a news carrier. (Courtesy of the New Egypt Press.)

Rush Warwick was born in 1885. He and his brother Harold owned and operated the stationery store on Main Street for 35 years. Both brothers were avid baseball players and took every opportunity to play in a game. They were also both musicians. They played with the New Egypt Band, in the Hope Hose Band of Bordentown, and even sometimes with Trenton bands. (Courtesy of Bill and Karen Kisner)

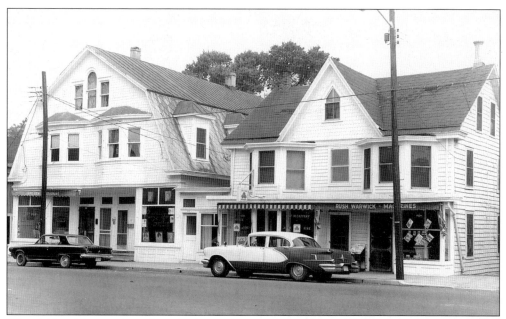

Warwick's sold everything from lead pencils to express wagons. The store was open from 7:00 a.m. until 11:00 p.m. (Sound familiar?) This photograph was taken at a later date when Rush Warwick's wife, Lydia, ran the shop after his death in 1962. McCaffery Insurance occupies the twin side of the building now. (Courtesy of the New Egypt Historical Society.)

Four generations gather together for a family portrait. On the left, sitting down and holding Frank Swain Jr., is Lizzie Fowler. To the right is Mother Fowler. Mary Fowler Swain, daughter of Lizzie and mother of baby Frank, stands in the back. Lizzie worked at the shirt factory in town. (Courtesy of the New Egypt Historical Society.)

This photograph was taken 14 years after Clara Tantum became the 1924 queen of the Lake Carnival, and she still looks beautiful. Tantum grew up on Magnolia Farm. She married famous aviator "Eddie" Burgin and had the good fortune to speak to her husband when he was more than 5,000 miles away and 5,000 miles up in the air. The conversation set a communication record. (Courtesy of Carol Reed.)

When Emile Henri Burgin volunteered for the air corps during World War I, the medical examiner rejected his request. He did his duty but kept his desire to fly. Later, Burgin took flying lessons. He performed flying stunts and wing walks. Burgin came in first in the New York–Los Angeles air race. In March 1929, he was one of the guest celebrities, along with Lindbergh, at the First Annual Aviation Ball, held at Roosevelt Field in New York. (Courtesy of Carolyn Lear.)

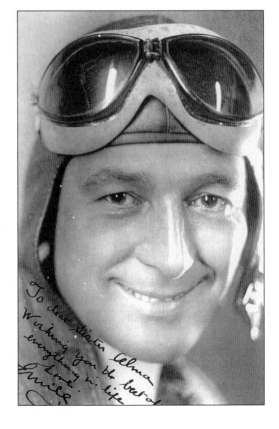

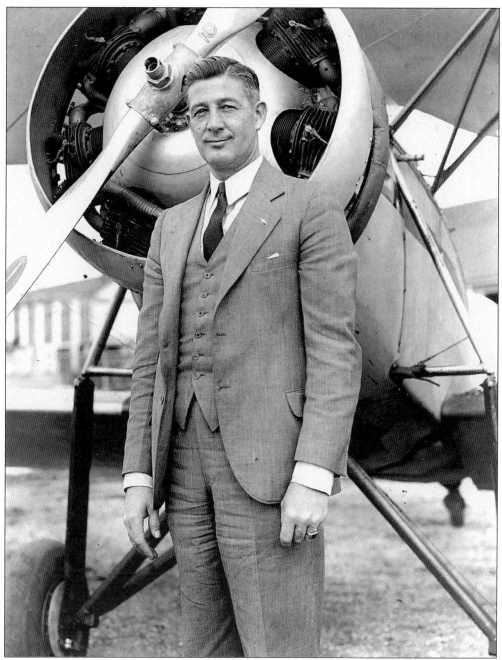

Emile, or "Eddie," Burgin, is shown here in front of his plane, the *Tee-Wee*. In 1930, he started to set aviation records. He began a 20,000-mile flight by flying down the west coast of South America. He continued up the east coast of South America and was forced into unscheduled landings 17 times. One landing was on Cayenne (Devil's Island), French Guiana, still a French penal colony. Farther along, his radioman, Zeh Bouck, stayed in Puerto Rico. Trouble erupted over the ocean soon after. His navigator, Capt. Lewis A. Yancey, sent out an SOS, and they landed in a salt swamp in the Bahamas. The craft caught fire, but Burgin and Yancey were unhurt. This was the first SOS successfully sent from an aircraft. (Courtesy of Carolyn Lear.)

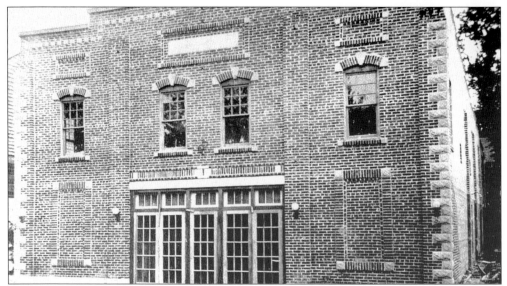

The Isis Theatre, named for the Egyptian goddess of agriculture and fertility, surely complemented the town's name of New Egypt. Built on Main Street by brothers Stuart and Milton Foulks, it was situated right next to their gas station. The theater held its grand opening before the end of the resort season. Saturday, August 27, 1921, was chosen, souvenir programs were distributed, and the curtain rose to show *Madam X*, starring Pauline Frederick. (Courtesy of the New Egypt Historical Society.)

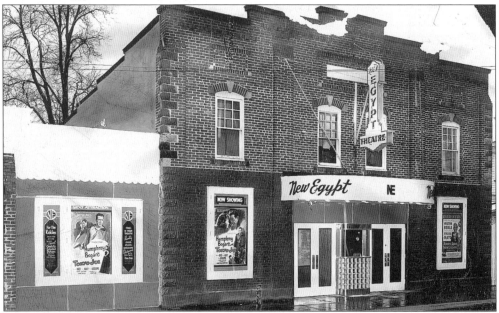

On February 10, 1950, there were new owners, a name change, and a grand opening announcement with free popcorn for everyone at the New Egypt Theatre. It was modernized with a new RCA screen and sound projection, air-conditioning, and comfortable upholstered interspring seats. *Tokyo Joe* played, with Humphrey Bogart in the starring role. These were the days of two films for one ticket. The second feature was *Always Leave Them Laughing*, starring Milton Berle and Virginia Mayo. (Courtesy of Bill and Karen Kisner.)

A scene from a play in the early 1920s has Costa consoling Elsie Vaughn. (Or is he the reason she is crying?) Local talent was plentiful, and theater was popular in New Egypt. Old Meirs' Hall also had shows and plays. When a show was about to begin, Rube Thompson, the town crier, walked through town announcing the show. (Courtesy of the New Egypt Historical Society.)

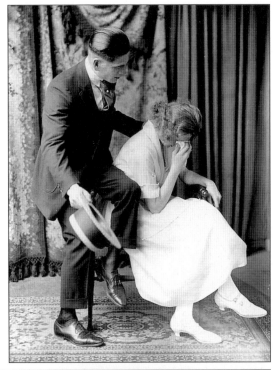

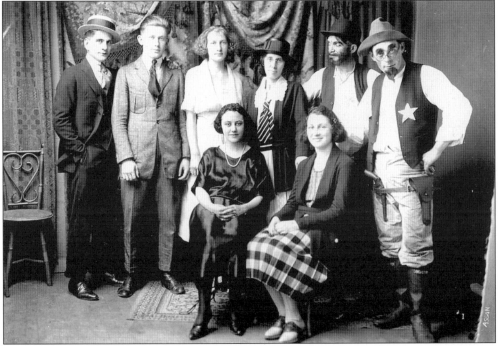

The cast lines up in this photograph for a photo shoot and some applause. Seated in the front are Elsie Horner (left) and Sis Hopkins. Standing are, from left to right, Costa, Red Harker, Elsie Vaughn, Lou Van Hise, H. North, and Muriel Thompson. The title of the play is long forgotten. (Courtesy of Bill and Karen Kisner.)

This was a sad day for all. The original Isis Theatre had gone through changes of owners, uses, and designs in its lifetime. Gone were the times that Prof. E.A. Stevens entertained at the piano. No longer would the lovely sounds of the New Egypt orchestra float up from the pit. The popularity and availability of television closed many theaters in the 1950s. Its last use was Morris Friedman's used furniture and antique shop. (Courtesy of the New Egypt Historical Society.)

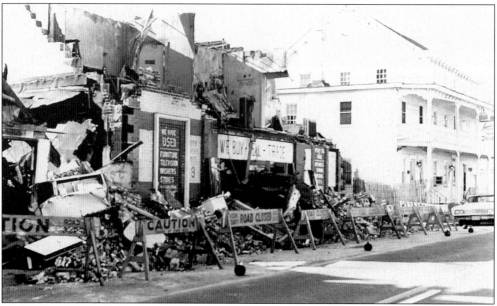

The poor Isis Theatre, devastated by fire, places a blot on the Main Street. It was much younger than the lovely American House in the background. In years to come, the American House also found its end by fire, on a very cold night that left icicles hanging from everything, including the fire hoses. (Courtesy of the New Egypt Historical Society.)

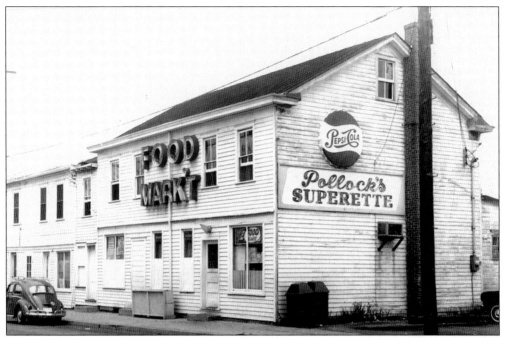

This building has always been used for a grocery and meat market. Charles Robbins opened his business in 1903 as soon as the building was completed. The upper floor was used for the meat products, the basement for storage of fresh vegetables. Pollock's Superette was located here for 27 years. (Courtesy of the New Egypt Historical Society.)

It looks like Jack Pollock is telling Anthony Horner what a great piece of ham he is selling him. He probably has a little comic saying to pass along too. The T-bone steak in the meat case is selling for 89¢ a pound, and the frying chickens cost 69¢ a pound. It is probably fresh local meat. (Courtesy of Bill and Karen Kisner.)

43

This photograph shows the old Chambers building getting another facelift. The front of the building has been changed a few times over the years, and the building has had many different occupants. One of the occupants of the 1950s was the Errickson soda shop. (Courtesy of Carol Reed.)

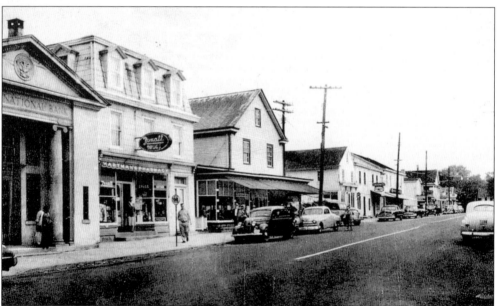

This street scene records some changes. First National Bank remains, although different men sit on the board. It is now Hartman's Pharmacy instead of Jones', and Shinn's still looks the same on the corner. The horses are completely gone now, and many more cars line the street. (Courtesy of the New Egypt Historical Society.)

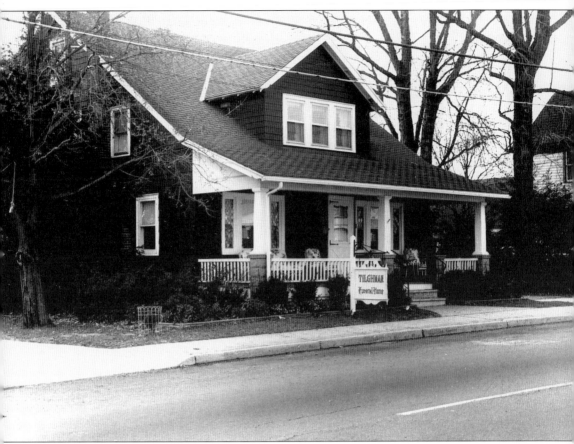

The photograph shows the house as it looked when Richard Tilghman arrived in December 1960 and opened the Tilghman Funeral Home. Tilghman is a descendant of Tench Tilghman, aide-de-camp to George Washington during the Revolutionary War. His famous two swords hang in the Old Senate Chambers in Maryland. A portrait of George Washington, the Marquis de Lafayette, and Tench Tilghman was painted by Charles Wilson Peale. Many years ago, when the Van Hise family lived in the house, a fire broke out on the coldest of nights. A portion of the house was saved and rebuilt by the Van Hises. When Katharine Van Hise died years later in Florida, she requested that she be shipped back to New Egypt and laid out in her old family home by Dick Tilghman. (Courtesy of the New Egypt Press.)

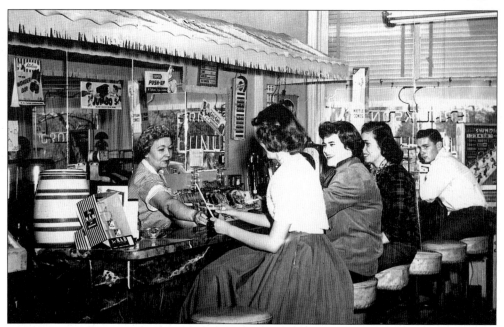

In 1955, a favorite stop for the teenagers was at Evelyn Errickson's soda shop in the Chambers building on Main Street. Errickson is behind the counter in this photograph, and the second girl in from the left is Lois Thomas (Palmer). Errickson was always happy to see the kids come in, and they were always happy to be there. (Courtesy of Bill and Karen Kisner.)

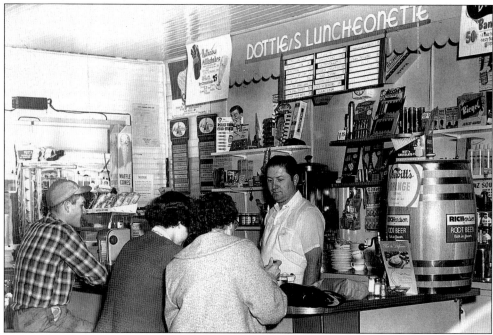

Ernie South is behind the counter at Dottie's Luncheonette. This was before it moved from its original location up the street to where the Plum Tree Restaurant is now. The big event took place just before the new firehouse was completed next door in 1961. They are selling Abbott's ice cream, and milk shakes are only 25¢. (Courtesy of Bill and Karen Kisner.)

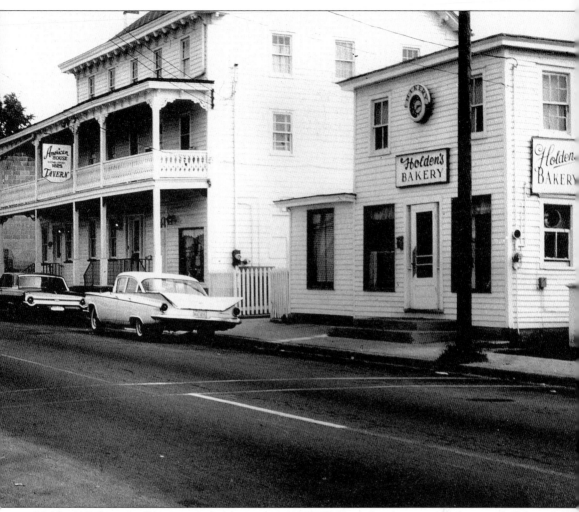

Holden's Bakery, with its warm baking aromas wafting from the doorway, had a wonderful reputation and did fine business while it was on Main Street. When the bakery closed, it was torn down to make room for parking alongside of the American House. The American House was one of the oldest hotels in town, dating back to the middle of the 1800s. D.W. Maloy bought the hotel in 1911, sold it to Harry Davis, and then bought it back again in 1913. Since then, it has had many owners. Some of them added wings to the outside or raised the roof to create a third floor. (Courtesy of the New Egypt Historical Society.)

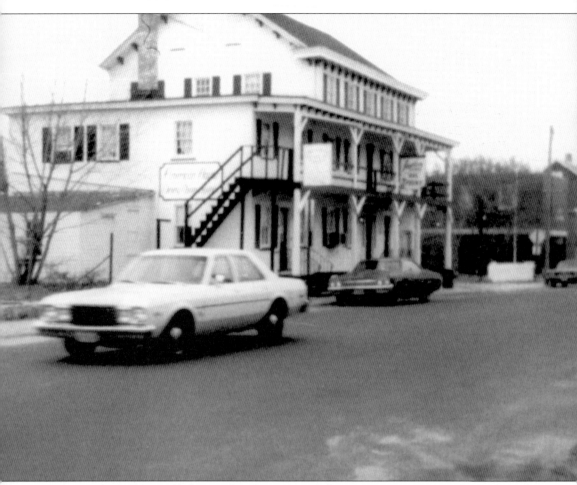

When Bob Goff's grandfather Arthur Letts owned the American House in the early 1940s, there were free cheese and crackers for the patrons every Saturday night. Goff's grandmother Cornelia made super-hot mustard to go with them. Occasionally, Letts made clam chowder and treated the customers to a free bowl. In those days, women were not allowed at the bar. They had to sit in the front room. That was a special, separate room for ladies. Letts sold the building in 1943. In later years, the owners were James Garafola, Woody Reynolds, Mike Walsh, and Bill D'Angelo. In the background is the law office of Jay Tractenburg. The Holden's Bakery building is gone. (Author's collection.)

Three
THE RURAL LANDSCAPE

The countryside in Plumsted abounded with fresh fruits and vegetables. It looks like these folks in 1940 know all about it. Aside from the many fertile farms in the area, the blueberries, cranberries, and many other berries grew wild. The smart ones brought along picnic baskets and made a day of it. (Courtesy of the New Egypt Press.)

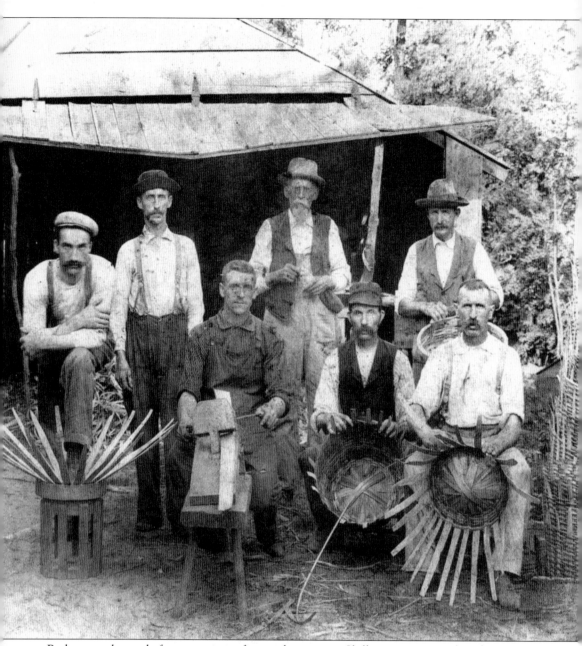

Baskets can be made from a variety of natural resources. Skill is necessary, rather than just an assortment of tools. With the many basketmakers recorded in the New Egypt–Plumsted area as early as 1800 and throughout the early 1900s, it seems that fathers passed the art down to their sons. There were 18 basket-manufacturing companies in the early 1900s in Plumsted. William S. Johnson manufactured a large quantity of baskets for government contracts and to New York City businesses in every size and description. Benjamin Reed Buckalew, Caleb Southard, and Harry and Ward Horner made white-oak splint baskets. Johnny B. Southard put his identifying mark under each basket he made. Oscar Buckalew wove baskets, but he and Oscar Southard were also renowned for their ax handles. James Arthur Buckalew was famous for his oyster baskets. (Courtesy of the New Egypt Press.)

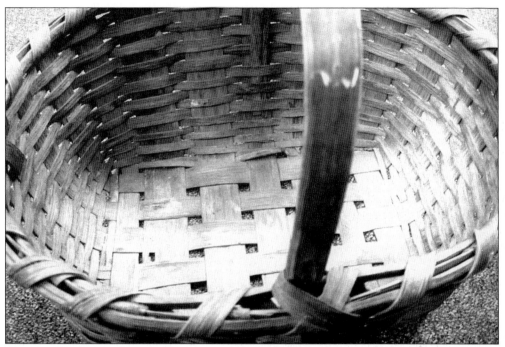

The art of basketry goes back a long way. American Indians and Colonials made full use of the natural abundance of material at hand. Caleb Buckalew and William Henry Buckalew were two basketmakers from the early 1800s in this area. Harry Emery and some of the Archers were basketmakers from a later date. This closeup photograph shows the weave of this collectible-quality Ward Horner basket. (Courtesy of Stacy Reed.)

Baskets were made from cornshucks, grass, pine needles, reeds, roots, vines, and splints off the local trees. They were put to use for toting oysters, clams, fish, and clothes and for picking berries and other fruits—all with different shapes and sizes that determined the use. This photograph shows a modern basket design. (Courtesy of the New Egypt Press.)

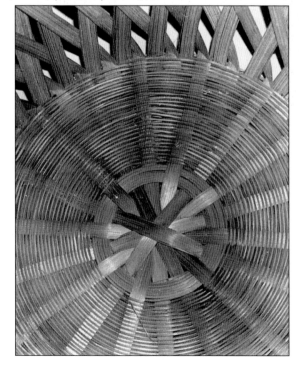

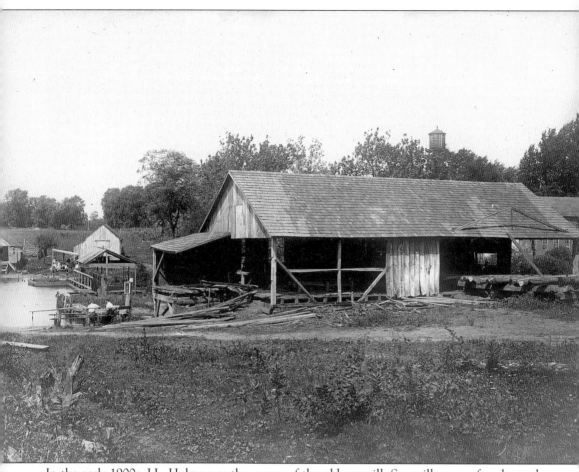

In the early 1900s, J.L. Hulme was the owner of the old sawmill. Sawmills were often located next to a body of water. The floor was situated so that sawdust fell through the cracks of the floor into the lake to wash away. In the background on the right is the old shirt factory. To the left of the sawmill is the dam across the lake. When this business ceased, Harry Worth took over and opened a moving picture parlor here. He called it the Casino. Success expanded the business into a dance hall, with live musicians coming down from the big cities. This was a popular spot for quite a while. The size of the hall made it perfect for practicing basketball, which was also becoming very popular. The lack of upkeep and repair caused it to disintegrate. (Courtesy of the New Egypt Historical Society.)

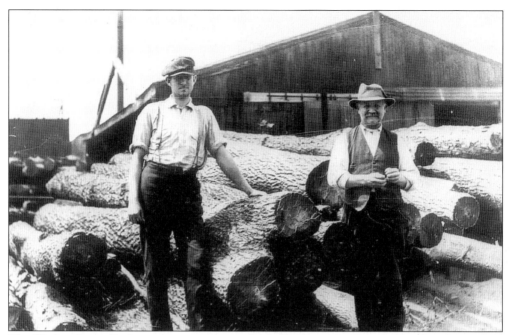

The Harker Sawmill, shown here, was located a half-mile up Jacobstown Road and one-third of a mile in from the road. Owner Ward Harker (right) is shown here with C. Ferdinand Van Horn. All the sawmills did well during this period of development for New Egypt. (Courtesy of the New Egypt Historical Society.)

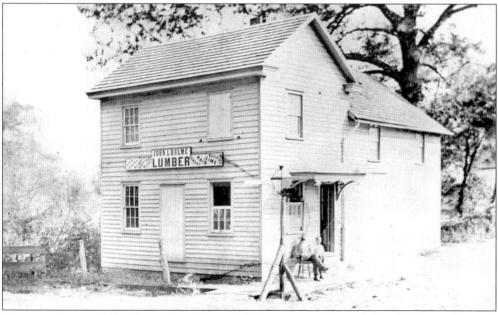

The several sawmills in Plumsted in the early 1900s were surely needed with the rapid growth of vacationers and folks wanting to live here. New hotels and homes were in various stages of construction. This view shows the John L. Hulme Lumber Company, located where Norman Bright took over. This father and son must be taking a break from the busy day. (Courtesy of Bill and Karen Kisner.)

The letter B is missing from the sign, but folks here know about Cranberry Canners Road. Elizabeth Lee, who owned acres of cranberry bogs with her brother Enoch Bills, took slightly damaged cranberries and boiled them with sugar. Happy with the result, she began to can them for later use. Her business, which made Bog Sweet cranberry sauce, grew rapidly. It became necessary to build a canning factory. This was a forerunner of Ocean Spray cranberry sauce. (Courtesy of the New Egypt Press.)

In 1789, an advertisement was posted that anyone harvesting cranberries before October 10 would be fined 10 shillings. Cranberries grew wild in the sandy soil of Plumsted. In the 1800s, Ephraim P. Empson owned 15,000 acres in Plumsted. One of his many endeavors was to farm cranberries. He was known as "the Cranberry King." This is a photograph of the old cranberry factory long after Ocean Spray moved to Bordentown. (Courtesy of the New Egypt Press.)

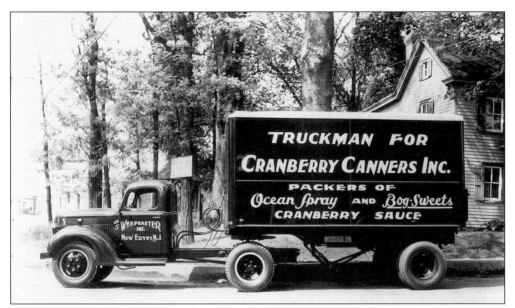

William F. Feaster has a new truck to carry the successful Bog Sweet cranberry sauce out to market. By this time, the business had merged with Ocean Spray in Bordentown. Ocean Spray was actually a cooperative formed in 1930 by the farmers in New Jersey and Massachusetts to market processed cranberries. Cranberries have become even more popular in juices and as snacks. (Courtesy of the New Egypt Historical Society.)

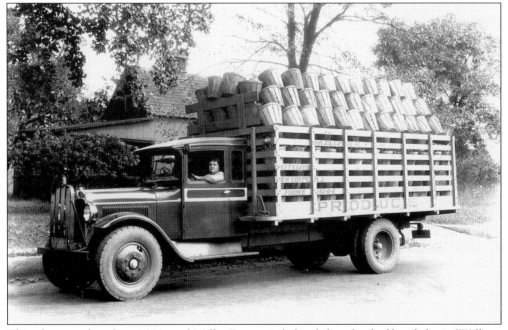

This photograph is from 1930, and Millie Feaster is behind the wheel of her father's (William F. Feaster) truck. She is driving a load of tomatoes, which will probably be transported by train to the Camden tomato-canning factories. There were times when the trains were so heavy with loads of Jersey tomatoes that they needed two engines to pull the cars up the slight inclines of ground. (Courtesy of the New Egypt Historical Society.)

Howard "Chicken" Davis purchased property in 1909. He built a chicken incubator, advertised as "the Largest Hatchery in the World." This is what tagged him with the nickname "Chicken." He built a home (called the Anice Home) on the bluff overlooking the Oakford Lake. During World War I, he invited the theater troupes that entertained at Camp Dix to use his home as their stopover. He and his son Joseph later drove an artesian well and created a pool they called the Birdbath. They added poolside amenities and provided facilities for private picnic gatherings. People came from miles around to swim and spend a pleasant afternoon playing shuffleboard or miniature golf. Joseph acted as a lifeguard. Eventually, a severe rainstorm brought destruction to the playground and collapsed the sides of the pool. They chose not to rebuild it. Joseph then turned the property into a horse farm. (Courtesy of the New Egypt Historical Society.)

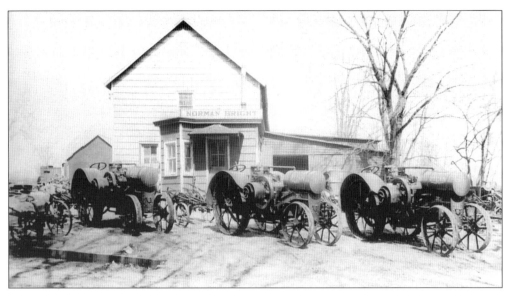

This tiny building was a beginning for Norman Bright. He bought the coal and weighing business from Herman Morton. The location next to the railroad tracks was perfect. He also offered other building supplies and items needed by the local farmers. Shown here are the first tractors in the area, lined up ready for sale. (Courtesy of the New Egypt Historical Society.)

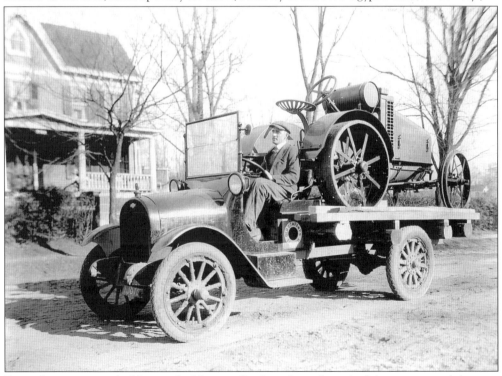

Expanding was a profitable one for Norman Bright, who is happily delivering one of the new tractors himself. This is a Chevrolet truck that he is driving. The sign under the seat says, "Old Company's Lehigh." Check out the side-view mirror on the truck. The tractor is an International. (Courtesy of Bill and Karen Kisner.)

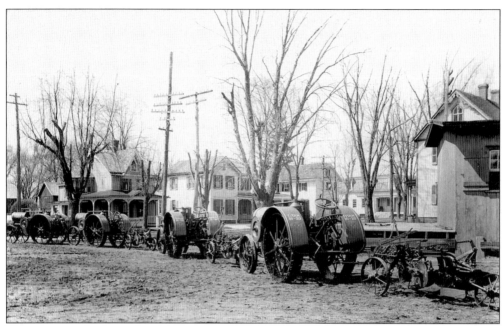

This photograph shows that Norman Bright's business on Evergreen Road is growing solidly. The tractors are stamped, "Titan 10-20." By now, he was the exclusive retailer for International Tractor Sales. A row of beautiful Victorian homes can be seen across the street. (Courtesy of Bill and Karen Kisner.)

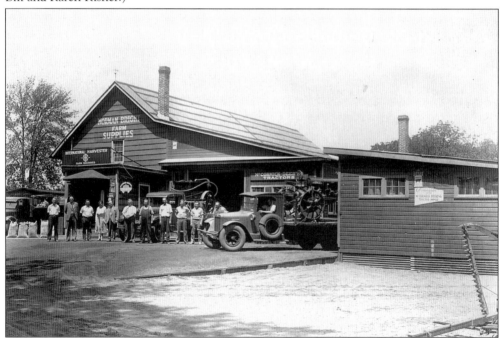

Several years later, Norman Bright's has grown even more. The building has expanded many times. He sells all kinds of farm equipment, including McCormick-Deering tractors, plus the International-Harvesters. The number of employees has grown as well. (Courtesy of the New Egypt Historical Society.)

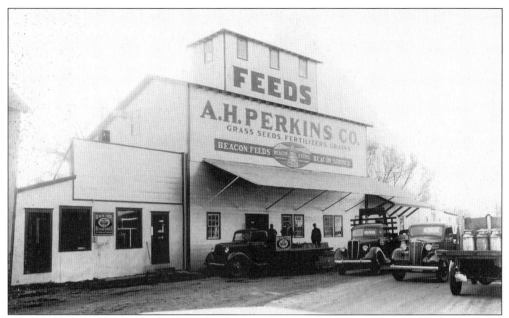

This photograph shows the front of the A.H. Perkins Feed Company before the fire of 1937. The building, located on Lakeview Drive, is three and a half stories high. The mill supplied all the surrounding farmers with the necessary grains, feeds, seeds, and fertilizers. Perkins paid nine-year-old Bob Goff 5¢ for every mouse he caught and 10¢ for every rat. Perkins supplied the bait and traps. (Courtesy of the New Egypt Historical Society.)

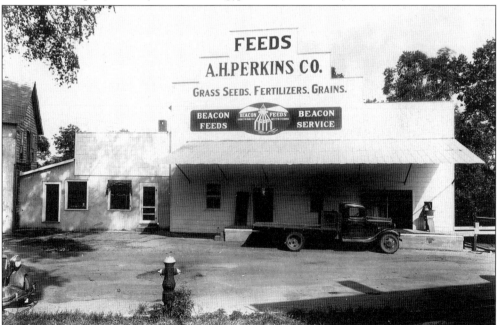

When Perkins's company caught fire one morning in May 1937, five fire companies responded. They fought the fire from three different angles. Most of the building burned. The new building was erected, and Perkins was back in business. It was his habit to walk up to Main Street twice a day for a shot and a beer and then return to work. (Courtesy of the New Egypt Historical Society.)

Clayton Boyer stands in the middle of this photograph in his office in 1950. His business was located where the New Egypt Elementary School stands now on North Main Street. He ran a sales stable and a flea market every Wednesday. His house and sales office were moved to Lakewood Road to make room for the school. (Courtesy of Bill and Karen Kisner.)

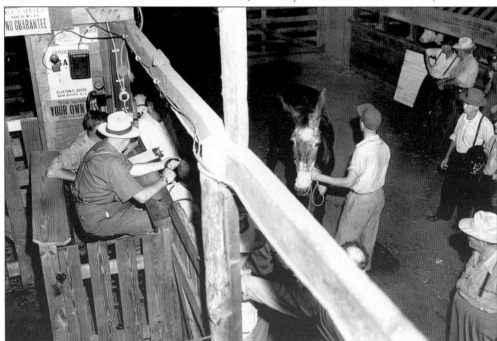

A burro is auctioned off at Clayton Boyer's on a Wednesday. The sign on the wall reads, "All animals sold as is. No guarantee." There is also a sign that reads, "You enter these premises at your own risk." The men loved coming in to buy or just stand around and jaw. (Courtesy of Bill and Karen Kisner.)

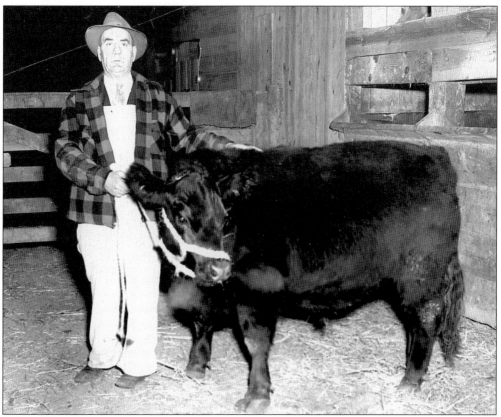

The sale of all sales took place at Boyer Sales Stables when an entire herd of Brown Swiss cows and one bull were sold at an average price of $336. The highest-priced cow brought $500. The bull brought $616.33. These were the highest prices on record in 1950. They were sold for Forman Hunt of Lincroft, New Jersey. (Courtesy of Bill and Karen Kisner.)

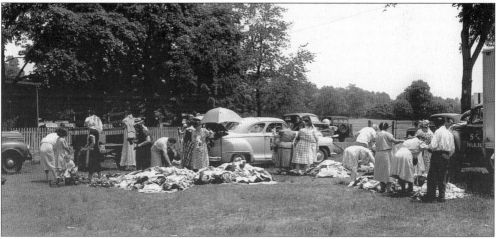

The flea market on Wednesday was always a big hit. Everything was sold from clothing, desks, furniture, farm tools, and gadgets of all kinds. People came from far and wide, bringing the babies with them and the umbrellas to keep the sun off their head. One truck here is from Philadelphia, Pennsylvania. (Courtesy of Bill and Karen Kisner.)

People could come out to Clayton Boyer's flea market every Wednesday and stay for the auction later in the day. This flea market was located in the area of North Main Street where the elementary school stands today. Later, a flea market and auction, affectionately known as "the Dogtown Mall," was created on Route 537. While the Boyer flea market is long gone, the Dogtown Mall is still operating and brings people from great distances to find bargains of all kinds.

Four
SERVICES

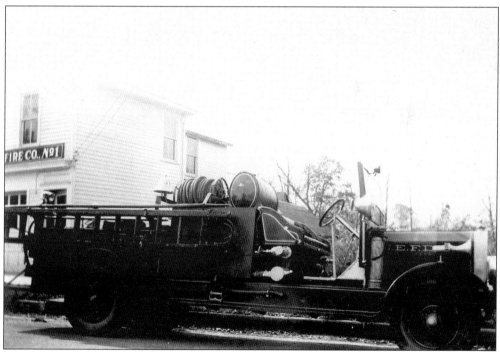

In front of the old firehouse on Evergreen Road stands this 1928 Childs ladder truck. The truck was insured for $5,000. The yearly premium was $46. In 1928, William T. Nash was president and William C. Van Horn was the fire chief. (Courtesy of Bill and Karen Kisner.)

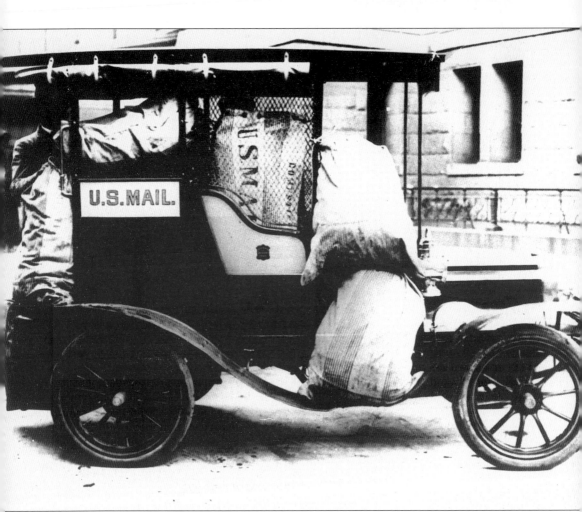

In 1845, when the proper name of New Egypt was established, Abigail Wallin filled the position of postmaster, which she ran from the Jordan House. A letter written in 1847 with a request to the postmaster general to install a daily mail route by mule from Bordentown to New Egypt replacing the weekly run was accepted. Envelopes were not in use yet; a person wrote a letter, folded it, and addressed the outside of the paper. Postage stamps became available at this time, but the mailer had the option of having the recipient pay the postage when they received it. It was 1855 before prepayment became compulsory. It was the early 20th century before the government began to use horseless carriages for practical mail delivery. Soon after, free rural delivery started. This ended isolation for many farmers. (Courtesy of the New Egypt Historical Society.)

By the time William "Paint" Chambers was appointed to the position of postmaster in 1897, he moved the mail office to his building, on the right, where he is standing. The women on the left are probably Emma Hartshorn, Myrtle Applegate, and Carrie Van Horn. They were the three switchboard operators at the Farmers Telephone Company, on the left side of the building. (Courtesy of the New Egypt Historical Society.)

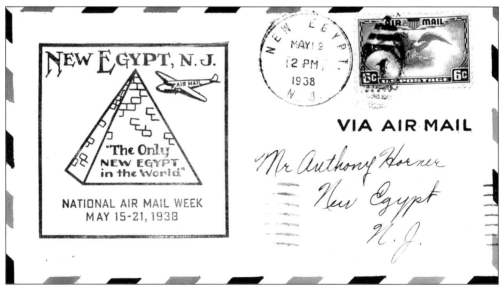

The post office commemorated New Egypt with a special envelope for airmail. They noted National Air Mail Week, May 15 through 21, 1938. Notice the stamp reading, "The Only New Egypt in the World." The mail was sent to Anthony Horner with just a 6¢ stamp. It was mailed at Camden at 6:30 p.m. and arrived in New Egypt at midnight. (Courtesy of Phil and Jean Horner.)

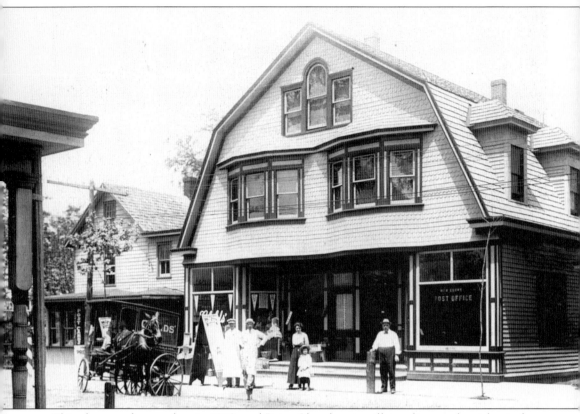

This photograph was taken in 1913, and Paint Chambers is still standing on the right, in front of the new building he erected in 1910 to house a post office. He installed all modern post office fixtures and a progressive atmosphere. Chambers was a painter and paperhanger before he received his appointment as postmaster. He also sold candy, novelties, stationery, newspapers, and cigars. By this time, he was a charter member of many local organizations and a prominent man about town. The woman to his left is Laura Moore, and the child is Elizabeth Compton. The store on the left is Child's, complete with delivery wagon. (Courtesy of the New Egypt Historical Society.)

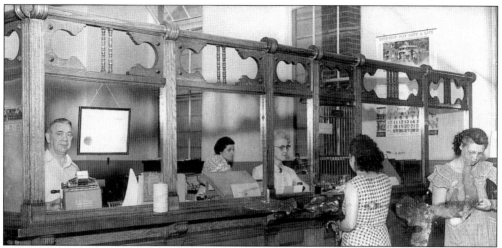

The First National Bank of New Egypt was chartered in 1906. It was housed at the Ivins J. Davis store. The first lineup of officers was president Ivins J. Davis, vice president William C. Jones, cashier George F. Compton, and assistant cashier William N. Nash. Individual deposits totaled $33,800.79. Complete resources were $67,634.39, and their capital was $29,000. The interior is shown here in 1955 after it moved up the street to what later became the municipal building. (Courtesy of Bill and Karen Kisner.)

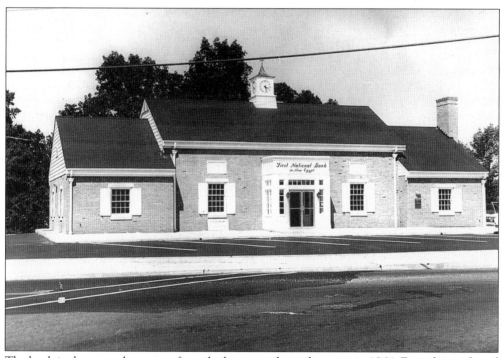

The bank is almost ready to open from the big move down the street in 1964. Everything is brand new. Lots of parking spaces are available for drive-in customers. The new location is at the corner of Main Street and Jacobstown Road, where the Colliers, Wall, and finally the Stanley Davis home stood. The house was moved to Jacobstown Road. Later, the bank merged with Bordentown Banking to form the Bank of Mid-Jersey. (Courtesy of the New Egypt Historical Society.)

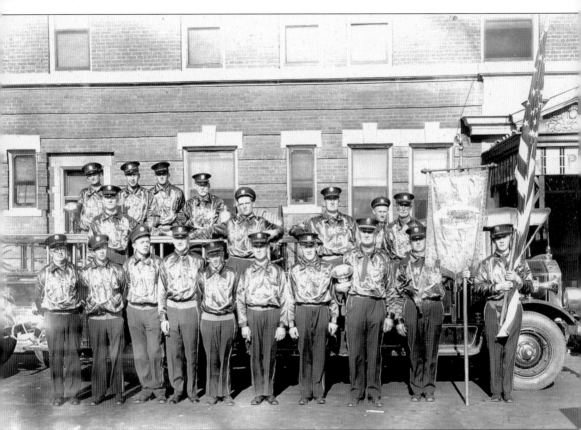

Shown here is a 1927 photograph of the New Egypt Volunteer Fire Company dressed for its parade in Atlantic City. To help out and do their share, the ladies of New Egypt held a card party in which $89.20 was raised for a donation. A gunning club donated a $21.66 profit from a refreshment stand on Decoration Day. May Delzell made the red blouses as part of the uniform. From left to right are the following: (front row) Edward Tantum, Roy Anderson, Howard "Jerry" Letts, Henry Dunkel, Vernon "Bugs" Nutt, John Halpin, Clarence Johnson, William C. Van Horn, Marvin Errickson, and Howard "Britches Dunfee; (back row) Roy Irons, William T. Nash, Leon Malone, Murrell Worth, John Murphy, Orval Errickson, Ferdinand Van Horn, Bob Buckalew, and Ed Dennis. (Courtesy of the New Egypt Historical Society.)

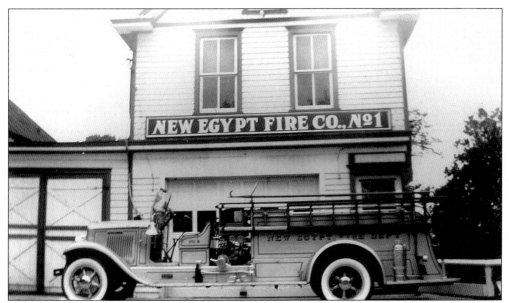

The 1937 International fire truck is all cleaned up and ready to go on parade or into service wherever it is needed. A couple months later, it was needed when A.H. Perkins Feed Mill on Lakeview Drive burned. The chassis for this truck cost $665. Frank Palmer donated a set of tire chains for it. It was later sold to the Cookstown Fire Company. (Courtesy of the New Egypt Historical Society.)

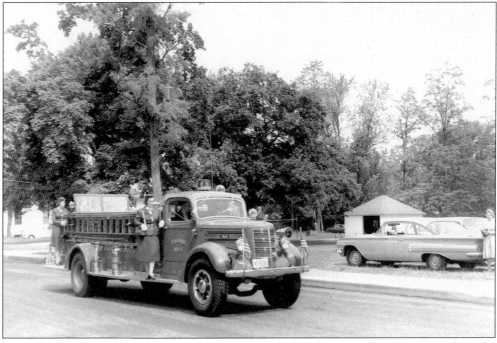

A much later model fire truck, probably the 1946 Mack, is in a parade. The women from the auxiliary are riding on it. They have helped the fire company a tremendous amount over the years in one way or another. The fire company was often invited to ride in parades in other cities. (Courtesy of Bill and Karen Kisner.)

Fire alarms were placed around town in 1903. The Union Transportation Company donated some "shoes" (rims) from locomotive wheels. These were hung on a bar between two posts. A sledge hammer would lie on the inner ring for a person to hit the rim. When the next person down the road heard the alarm, he in turn would bang his nearest alarm and so on until it reached the firehouse. They did lose a few hammers now and then. In 1927, a man destroyed an alarm at Brown Street and North Main. He was told that he could be prosecuted if he did not fix it. He fixed it. (Courtesy of the New Egypt Historical Society.)

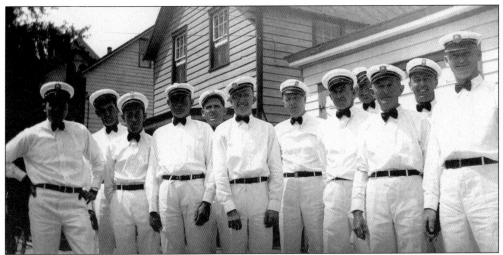

New clothes were sometimes purchased by firemen for riding in parades and competitions where they often won prizes. These people chose to dress in white. Thirty white caps, pants, and black neckties purchased for the members cost $47.75 at the Samuel Stevens store in 1937. In this year, John Lewis was president and Samuel Kirby was the fire chief. (Courtesy of Bill and Karen Kisner.)

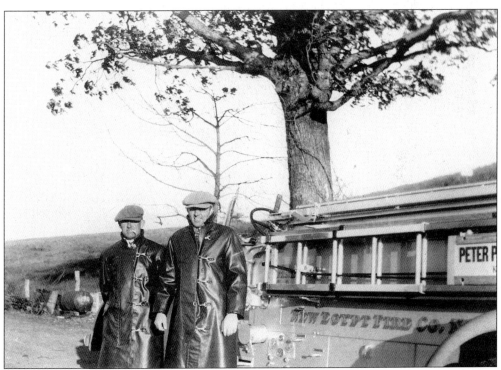

In October 1939, Orval Errickson and Jake Fisher made the trip to Kenosha, Wisconsin, to pick up the new Pirsch pumper. "New Egypt Fire Company No. 1" looks good painted on the side. The pumper cost $5,000. Here, they have stopped for a brief rest and to have their photographs taken. Proudly, they are showing the new coats purchased earlier that year from American LaFrance at $8 each. (Courtesy of Bill and Karen Kisner.)

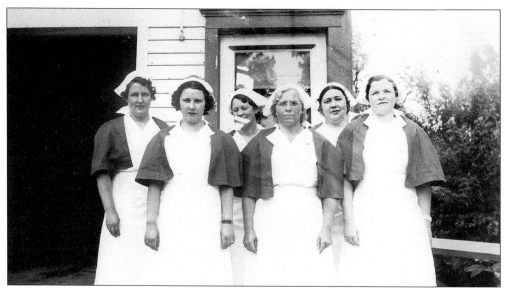

By July 1937, "the Ladies of the Fire Company" had long since become the Ladies Auxiliary. This photograph was taken in front of the firehouse before they walked in the Trenton Fair parade. They won first place for the auxiliary. Carrie Chafey made uniforms for the auxiliary. The New Egypt Fire Company took third place the same day. (Courtesy of the New Egypt Historical Society.)

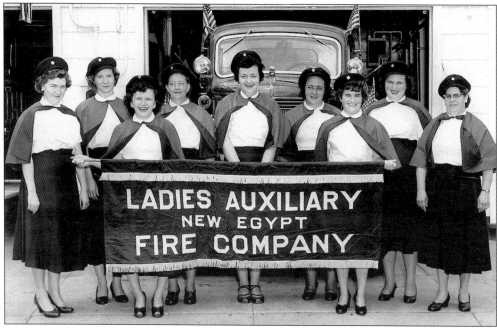

The Ladies Auxiliary supported their firemen starting in 1902, when they helped produce the New Year's Eve dinner at the Odd Fellows Hall. It was the first oyster dinner of many to be held, and they have been there ever since, raising money and donating it to the fire company. This is the Ladies Auxiliary in 1955. From left to right are Gwenn Huss, Wilma Grant, Ruth King, Dot Ivins, Julia Johnson, Evelyn Hartshorn, Lois Palmer, Lizzie Halpin, and Laura Moore. (Courtesy of the New Egypt Historical Society.)

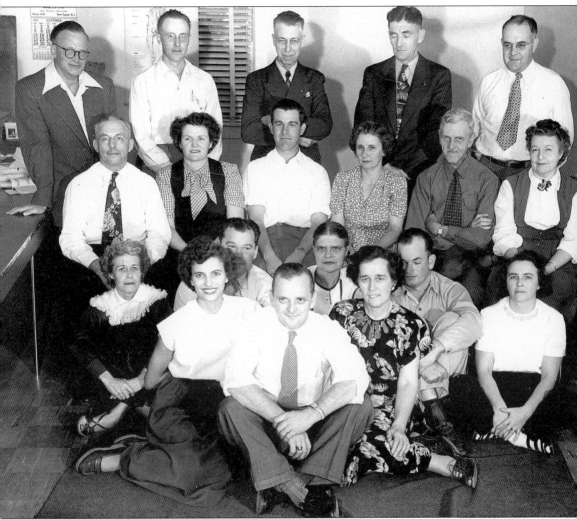

In 1937, the fire company expected to create a first-aid squad from within the membership including the honorary and exempt members. After a few months of discussion, however, that idea was shelved. The first-aid squad soon became its own entity with its own rules and regulations. The three members seated in the first row are unidentified, but the rest are, from left to right, as follows: (second row) Betty Hopkins, unidentified, Irving Walker, Wilamina Woodward, Raymond Grant, and Florence Palmer; (third row) Ted Ivins, Ann Ryan, Kenny Ivins, Nola Johnson, Frank Davis, and Jennie Horner; (fourth row) Albert Hewlett, unidentified, Hulme Woodward, Floyd Hopkins, and Albert Johnson. The photograph is probably from the 1940s. (Courtesy of Bill and Karen Kisner.)

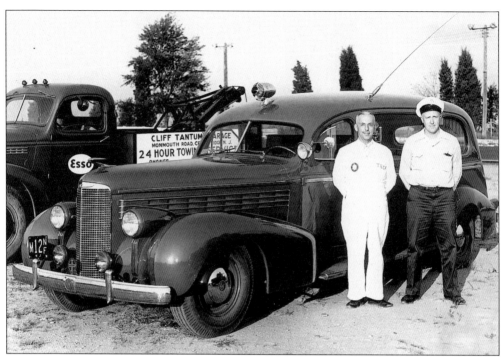

In this photograph, first-aid president Ted Ivins is on the left and Capt. Tom Hartshorn is on the right. The little red cross on the front of the bumper depicts first aid. The tow truck in the rear belongs to Cliff Tantum's Garage. (Courtesy of Bill and Karen Kisner.)

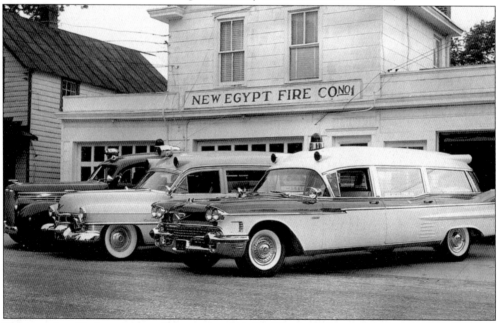

Here are the old, the newer, and the newest fine Cadillac ambulances lined up ready for service. The fire company allowed the first-aid squad to use their firehouse for meetings and to house their ambulances. The first-aid squad eventually attained their own building. (Courtesy of Bill and Karen Kisner.)

Five
ORGANIZATIONS

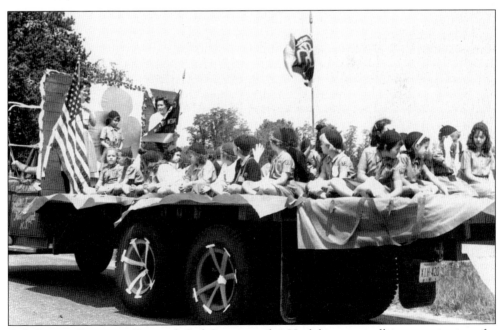

Cub Scouts, Brownies, Boy and Girl Scouts, and 4-H clubs are excellent organizations for growth in children and in communities. These youngsters are participating in a Memorial Day parade and loving it. (Courtesy of the New Egypt Press.)

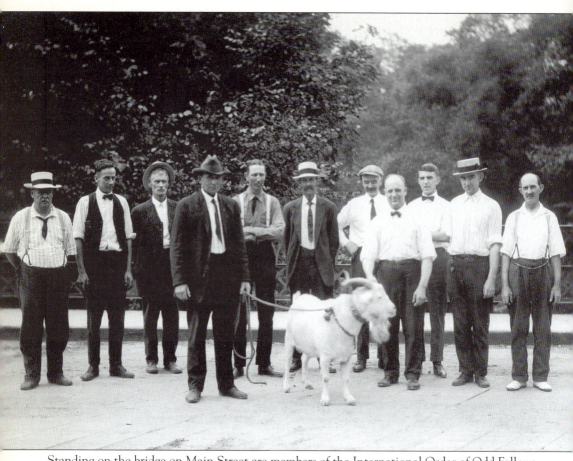

Standing on the bridge on Main Street are members of the International Order of Odd Fellows lodge. Holding the goat's leash is George Potter. Holding the goat's horn is Harley Henderson. In the back row are, from left to right, William "Paint" Chambers, Carlton Norcross, Daniel Bussom, Chester "Shine" Van Hise, Charles Tantum, Harvey Moore, Earl Moore, Rush Warwick, and Oliver Cox. It is believed that the original Odd Fellows lodge was formed because some men traveled in their business, not staying in one town. Hence the "odd" meant that a man was not associated with a guild. In 1819, Thomas Wildey, an Englishman living in America, formed a North American lodge. Their motto was "Visit the sick, relieve the distressed, bury the dead, and educate the orphans." By the time Wildey died in 1861, there were 200,000 members representing 42 states. (Courtesy of the New Egypt Historical Society.)

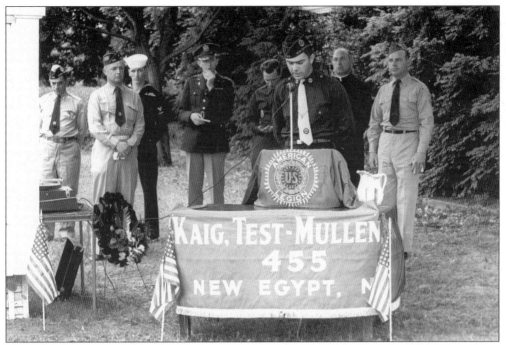

Every Memorial Day, the American Legion McKaig, Test-Mullen Post No. 455 in New Egypt held a ceremony. This photograph was taken in 1957, when the legion was located in the Mill House on Main Street. The American Legion was founded in Paris, France, in 1919 by members of the American Expeditionary Forces. (Courtesy of Bill and Karen Kisner.)

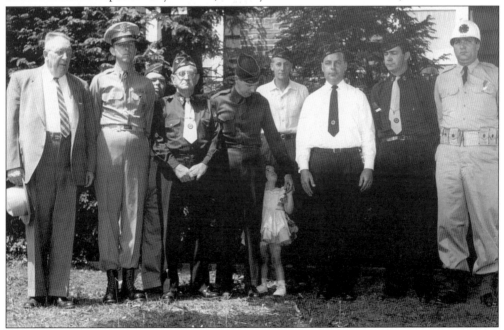

Everyone is standing at attention as the ceremony continues, but a little girl can always get a smile when she needs one. The first "flag code" offered by the American Legion was adopted by Congress in 1942. (Courtesy of Bill and Karen Kisner.)

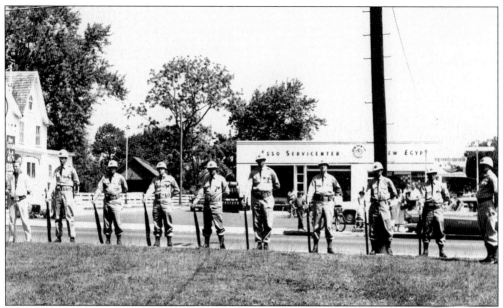

The 1950 ceremony continues as youngsters on bikes watch from across the street. The military was always willing to send soldiers for a formal memorial to our veterans. Notice the Esso sign in the gas station. That is a sign of the past. (Courtesy of Bill and Karen Kisner.)

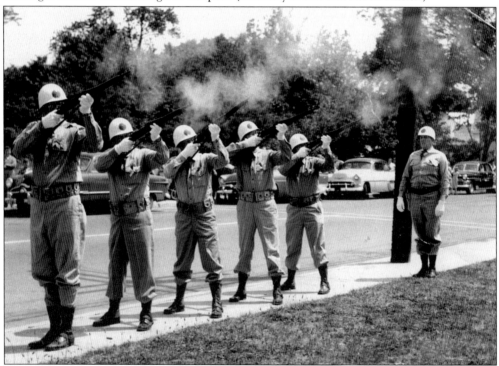

The same Memorial Day ceremony of 1950 continues with a salute to our veterans. Notice all the cars lined up across the street. The American Legion is also responsible for the GI Bill of Rights being signed into law by Pres. Franklin Delano Roosevelt. Post No. 455 later relocated to Meadowbrook Lane. (Courtesy of Bill and Karen Kisner.)

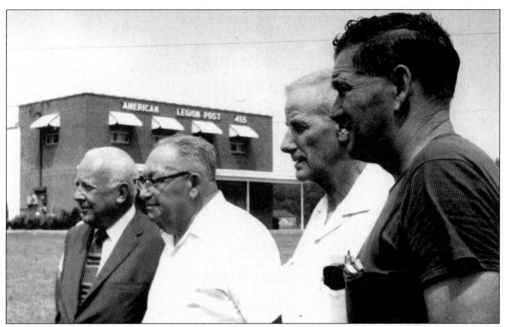

These four men gathered together c. 1967 at the American Legion Post No. 455 are, from left to right, Howard Lamberton, John S. Inman, Thomas Margrie, and George Mattson. Mattson was with the Jersey Central Power and Light Company for many years. (Courtesy of the New Egypt Press.)

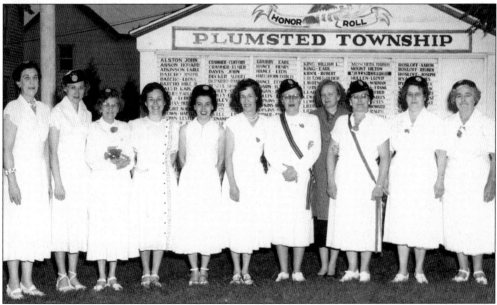

Congress chartered the American Legion in 1919 as a wartime veterans' organization. The work of the auxiliary to help the legion in their great work for America was a statement by a member. The auxiliary members of the McKaig-Test-Mullen Unit enjoy their time together while having their photograph taken. From left to right are Kate Boyer, Pearl Moschera, Sadie Moore, Louise Kole, Barbara Moschera, Frances Wurtz, Gertrude Walker, unidentified, Leila Brown, Laura Moore, and Jennie Walton. (Courtesy of the New Egypt Historical Society.)

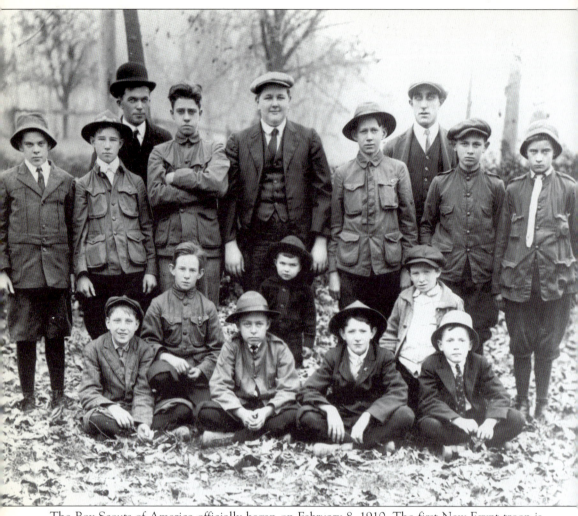
The Boy Scouts of America officially began on February 8, 1910. The first New Egypt troop is shown here in 1917. By this time, every state was represented with Boy Scout troops. Awards for heroism and honor were instilled. The motto "Be Prepared" was adopted. From left to right are the following: (front row) Walter Fredrichs, Joseph R. Davis, Edward Horner, unidentified, Stanley Moore, Mahlon Stevens, and George Worth; (middle row) Clarence Johnson, Guy Davis, Forest Bright, Thomas Van Horn, Lindley Reed, John Dunfee, and William Irons; (back row, Scout leaders) Harry Worth and Fred Chamberlain. Full resources of the Scouts were placed at the service of the federal government under the slogan "Help Win the War." This sentiment drew thousands of boys into Scouting. (Courtesy of the New Egypt Historical Society.)

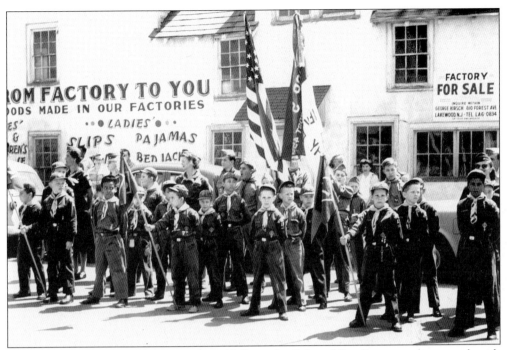

Lining up for the Memorial Day parade in 1963 are the Cub and Boy Scouts ready to march with pride down Main Street. They are standing in front of the old shirt factory. By this time, the Scouts and Explorers of America were reporting to President Kennedy, who had been a Boy Scout at one time. Membership by the end of this year totaled 5,446,910. (Courtesy of Bill and Karen Kisner.)

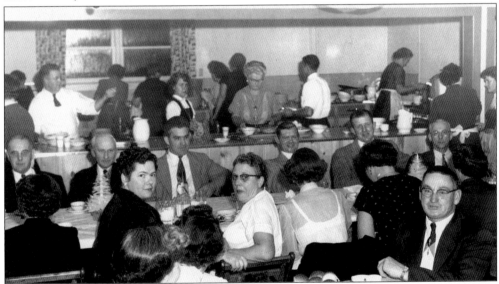

The Masonic Pyramid Lodge No. 92 held a Christmas party in 1954. Some of the people identified are Carleton Johnson, Elsie Flack, Kenneth Potter, Ted Ivins, Eva and Edward Tantum, Andy Bullock, Vincent Brown, Albert Johnson, and Marion Myroncuk. The Masons are a fraternity devoted to high ideals and admirable benevolence. They believe in community service and charitable work. (Courtesy of Bill and Karen Kisner.)

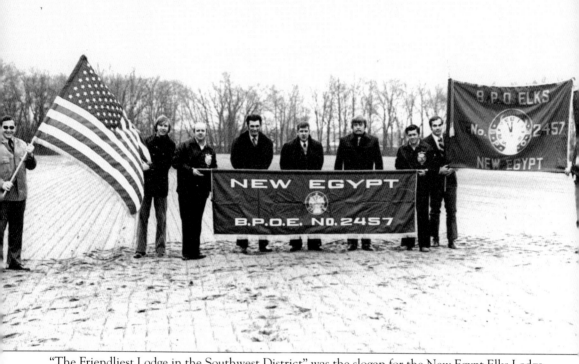

"The Friendliest Lodge in the Southwest District" was the slogan for the New Egypt Elks Lodge No. 2457. It was not easy, but the lodge worked together and finally bought land for their own building. Seen here delighted to stand on their own ground are, from left to right, John Gilmer (holding the American flag), Paul Mullen, Bob Tilghman, Bill Lyon, George Ward, Mike Walsh, Tom Fields, Duane Lear, and Joe Layton. The charter members numbered 150. The plaque inside the lodge names Donald Mallow as chairman and Joseph Layton, Frank Paschal, and John Yorke as committee members. It took years of planning, and the group met at Rova Farms, the Catholic church in New Egypt, and at the firehouse. When the group was finally granted a charter, Robert E. Tilghman served as the very first exalted ruler. (Courtesy of the New Egypt Press.)

Six
SCHOOLS AND CHURCHES

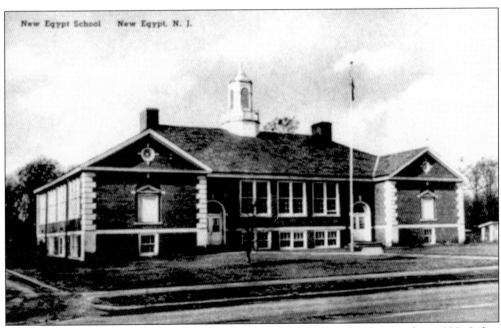

Called the modern brick school, this New Egypt Elementary School opened in 1929. It has been added onto, and the land surrounding the school has been enlarged. Author Dorothy L. Mount taught school for 42 years, and 35 of those years were spent here. Myrtle Moore started out teaching at Archertown and then came into New Egypt as a teaching principal. (Courtesy of the New Egypt Historical Society.)

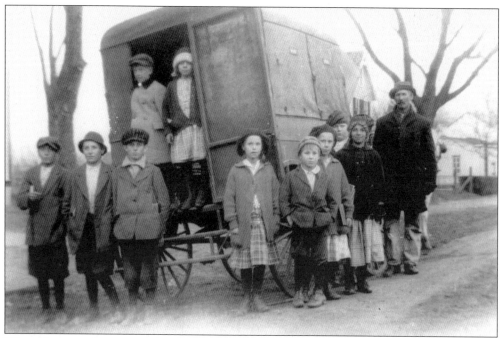

When the township consolidated the school system, Brindletown was the first to send their students into New Egypt in 1913. George Irons Jr. was a teacher in Brindle Park. This photograph shows the horse-drawn "school bus" driven by Edward Collis. When the weather was nice, the sides were rolled up. When it was cold, they stayed rolled down and straw was scattered on the floor to keep the feet warm. (Courtesy of the New Egypt Historical Society.)

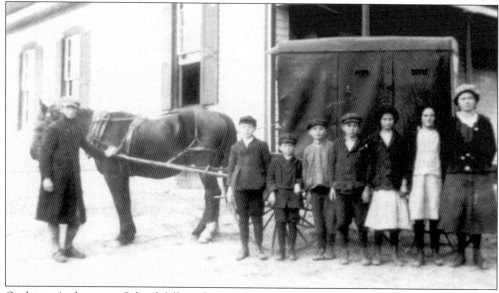

Outlying Archertown School followed suit and sent their grammar school students into New Egypt in 1919. Ella Hankins was one of the teachers in Archertown. Another township teacher in the early 1900s was May Norcross in Millstream. After 1910, the eighth-grade graduates took the Union Transportation train into Pemberton to complete their high-school years. (Courtesy of the New Egypt Historical Society.)

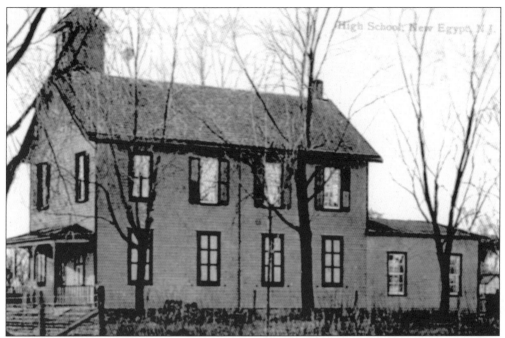

Public education was mostly unheard of in New Jersey before the Civil War in 1861. Before then, there were religious and private schools or private tutoring. In 1875, an amendment was adopted to declare the state provide an education system for all children between the ages of five and seven years. In 1913, education was compulsory for all children up to the sixth grade. This is an early New Egypt school, expanded in 1907 to include the high-school grades. (Courtesy of the New Egypt Historical Society.)

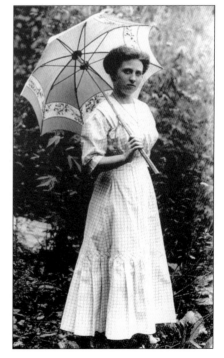

Carrie Dennis Van Horn was the wife of New Egypt Elementary School Board president Ferdinand Van Horn. Carrie ran the school cafeteria and was noted to run a tight ship. She also stepped in as deputy tax collector for the town. Ferdinand was also secretary for the New Egypt Fire Company for 37 years. (Courtesy of the New Egypt Historical Society.)

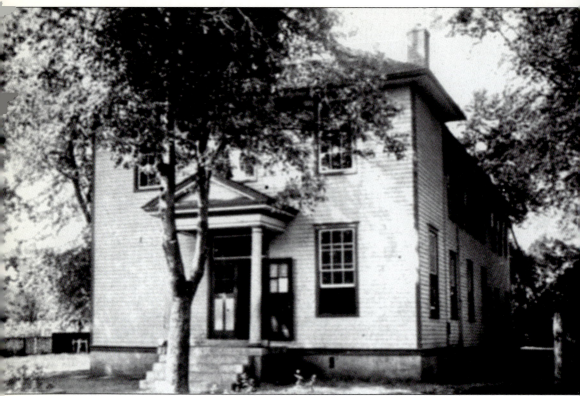

W. Clement Moore taught for five years in Plumsted and then returned to fill the position of principal of the grade school in New Egypt. Eventually, he became general manager of *School News of New Jersey*, the state educational journal. He graduated into real estate, notary, and insurance but always kept a large interest in publishing journals and magazines. He was honorary vice president of Lincoln-Jefferson University. The proceeds he received from the books he wrote on the Jersey scene and the poems he wrote on Jerseyana went to the restoration of the historical Zion Church. (Courtesy of the New Egypt Historical Society.)

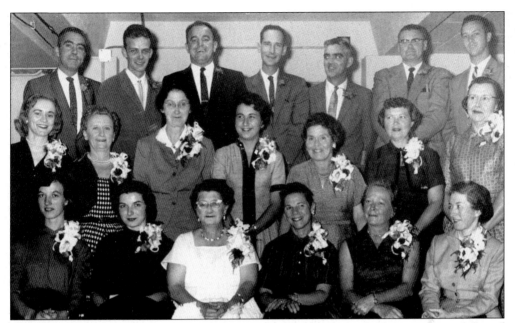

These are familiar faces of New Egypt Elementary School teachers who have taught and shaped so many children. They are gathered together to be honored, as their corsages indicate. The time is the 1950s. (Courtesy of the New Egypt Press.)

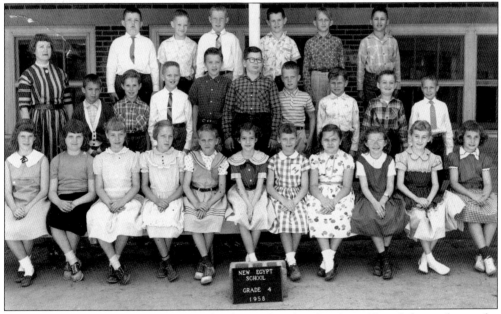

The fourth-grade class at New Egypt School in 1958 is lined up here. From left to right are the following: (front row) Nancy Emley, Edith Grant, Jean Fowler, Nancy King, Cathy ?, JoAnn Lawrence, Donna Garland, Jackie Lenceski, Mildred Mietsch, Marsha Viola, and Joyce Vierra; (middle row) Dorothy Mount (teacher), Eugene Reilly, Bruce Leidtka, Michael Strange, Ted Hamer, Lynn Baldauf, Michael Southard, Irvin Carter, Walter Earley, and Bruce Gollnick; (back row) Robert Byrd, George Turner, Ken Gomany, John Begley, Darrell Brenner, and William Kisner. (Courtesy of Edith Hlubik.)

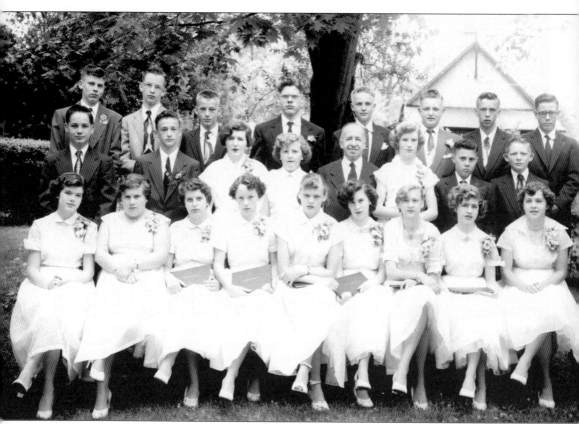

These eighth-grade graduates have walked down to Evergreen and Fort Avenues to have their photograph taken at Howard Asson's Studio in 1954. The photograph session was the tradition for all the graduating classes. Another tradition was for the girls to wear white dresses and corsages. The boys were expected to wear jackets, ties, and a boutonniere. Shown, from left to right, are the following: (front row) Linda Katherine Edmonson, Virginia Brocklebank, Gayle Moore, Jacquelin Stillwell, Renate Uta Riemann, Doris O'Donnell, Nellie Shuey, Audrey Marks, and Leona Schafer; (middle row) Boyd Belknap, Wesley Grant, Catherine Penn, Carolyn Buckalew, ? Adams (teacher and principal), Rita Nuss, August Moschera, and William Fredenburg; (back row) Edward Wilson Jr., Ronald Rockhill, Thomas Kelly, John Ungaro, Bernhardt Sander, Frank South, Hugh Byrne, and Robert Darby.

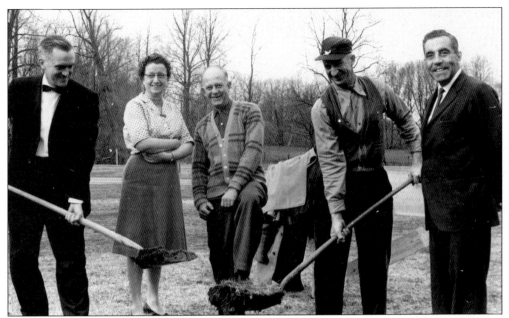

Breaking ground for another new school wing for the New Egypt Elementary School in 1964 is a happy occasion for these school board members. From left to right are John Lawrence, Vera Miller (secretary), Tony Horner, Tony Wikswo, and principal Arthur Burnham. (Courtesy of the New Egypt Historical Society.)

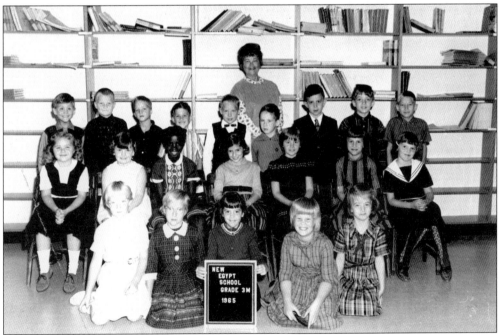

The New Egypt School third-graders smile their prettiest smile for the class photograph in 1965. The teacher standing behind all the students is Dorothy S. Mount. She is also a historian and has since become the author of the popular book A *Story of New Egypt and Plumsted Township*. (Courtesy of the New Egypt Historical Society.)

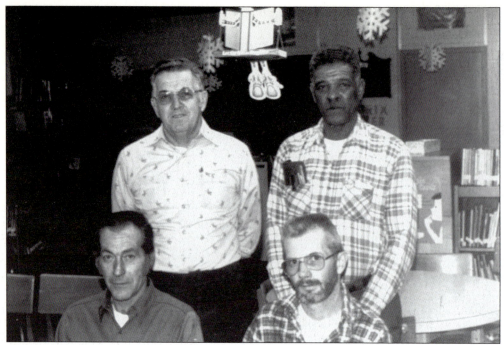

Children remember particular people when going through school. Especially well remembered are the mechanics that took physical care of the school. These people were seen on a daily basis, doing their jobs, not realizing they were being noticed by every kid in school. Pictured here are the longtime caretakers of New Egypt Elementary School. They are, from left to right, as follows: (front row) Jimmy Moore and Hilton Buckalew; (back row) Warren Grant and Roy Morris. (Courtesy of Edith Hlubik.)

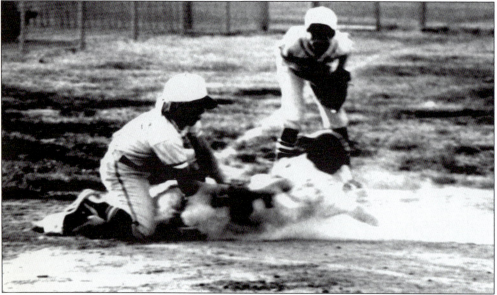

An after-school activity for many youngsters is baseball practice. This undated photograph shows an exciting part of the game—sliding into home plate. Baseball has always been a part of New Egypt from the very early days of the game. (Courtesy of the New Egypt Press.)

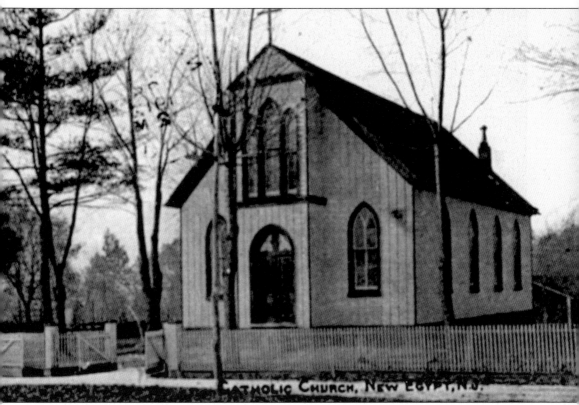

Elders Orson Pratt and Lyman E. Johnson of the Church of Latter-Day Saints, otherwise known as Mormons, came to New Jersey in 1832 and reached Hornerstown soon after. By 1841, there were 100 members in the Hornerstown, then Monmonth County, branch. Abraham T. Burtis, husband of Sarah Wright, was confirmed by Elder Erastus Snow as an elder and chosen president of the New Egypt branch in 1837. Fifteen others were baptized that day in September. Sarah Wright Burtis, later Hopkins, gave depositions stating that Brigham Young and Sidney Rigdon came to visit them. The church building, shown here, was sold to the Catholic diocese and moved to Railroad Avenue. An official reorganization of the Hornerstown branch took place in 1875. Congregation names from the 1800s are Appleby, Baxter, Branson, Brown, Chambers, and Chafey. (Courtesy of the New Egypt Historical Society.)

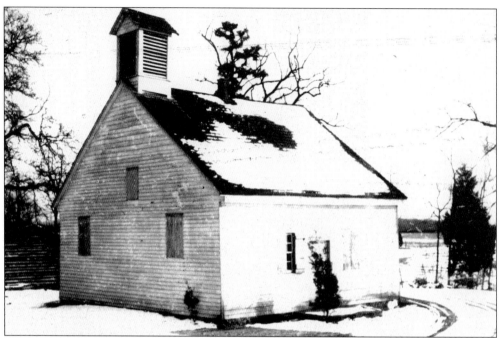

John Wesley's plan for the Methodist was multiple meeting places along a circuit or "charge." Preachers with a good horse and a passion were appointed to the circuit. Joseph Cromwell introduced Methodism at Hornerstown in the late 1700s. Meetings were held in private homes prior to this Zion church being built on Lakewood Road in the fall of 1800. Job Horner was one of the earlier homes to hold the meetings in this area. (Courtesy of the New Egypt Press.)

Job Horner owned a farm and donated an acre of ground for the Zion Methodist Episcopal Church to be built and for use of a graveyard. In December 1837, soon after the members of the board of trustees were elected, the church burned down. By next autumn, an improved building was erected at the same location. It was 1838 before the trustees received a deed for the property from Joshua and Fuller Horner. The church was dedicated by Rev. Dr. William Mann. (Courtesy of the New Egypt Press.)

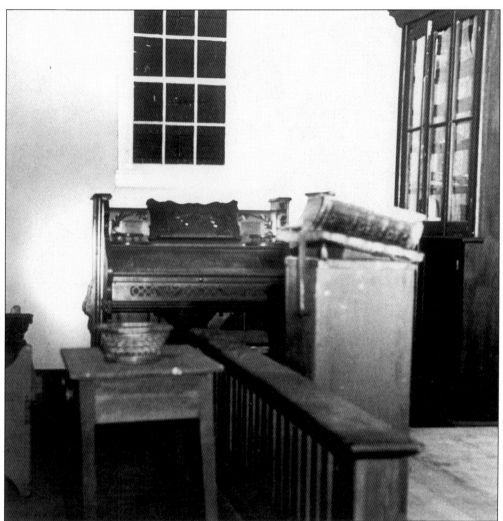
The interior of the church was well furnished with benches and the fashion of the day, a pulpit highly elevated. Francis Asbury, the founding bishop and most important figure of American Methodism, preached at Zion. He eventually traveled 270,000 miles and preached 16,000 sermons on the circuits. He lived the discipline he felt necessary when a preacher heard the call of God. (Courtesy of the New Egypt Press.)

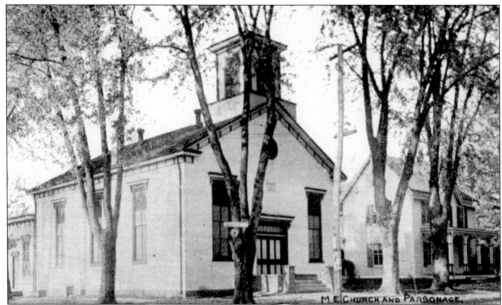

In December 1784, the famous Christmas Conference held in Baltimore, Maryland, was for the preachers to chart the course for the Methodist movement in America. Education in the Sunday school was strongly encouraged. This church was built in 1851 at Fort and North Main Streets, on land donated by George F. Fort. Later, the Sunday school was built on the back. In 1904, there were no quarterly or public collections taken for the entire year. (Courtesy of the New Egypt Historical Society.)

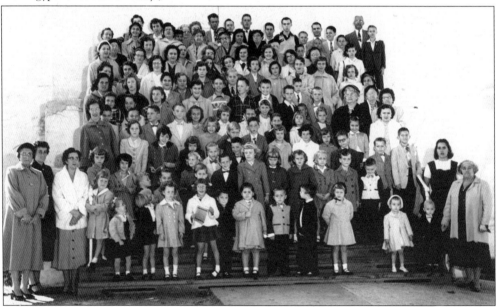

On a bright sunny day in October 1955, the entire Sunday school gathered together outside the Presbyterian church to have their photograph taken so that all may enjoy this memory forever. There are too many to name, but here are a few: Mildred Ivins, Jean Bayliss, Jennie Walton, Eva Tantum, Ruth King, Don Lear, Bill Cash, Larry Van Hise, Kirk Hudson, Ted Ivins, and Pat Tantum. (Courtesy of Carolyn Lear.)

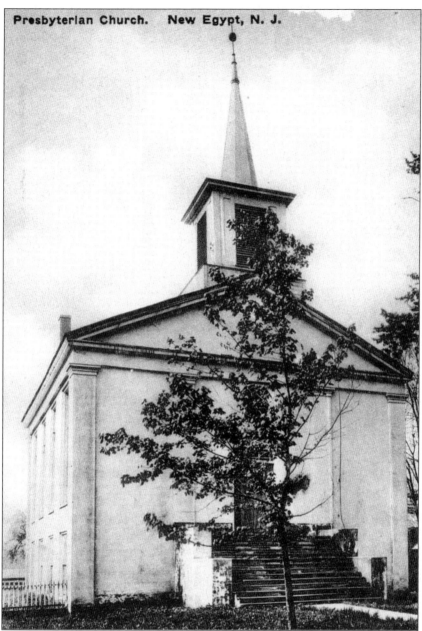

Francis Makemie, "the Father of American Presbyterianism," came to America from Ireland in 1683 to found Presbyterian churches. Nearly 100 years later, John Witherspoon, Presbyterian minister and educator and president of the College of New Jersey (now Princeton University), was the only active minister to sign the Declaration of Independence. The Presbyterian church in New Egypt was originally a brick building dedicated in 1851. Rev. George C. Bush was the organizer and its first pastor. James and son George W. Shinn shared a responsibility in building and supporting the early church. In 1955, the church steeple was struck by lightning and the bell cracked from the heat of it. A shorter steeple was installed, with an electric chime system replacing the bell. At this time, a new weather vane was also erected to replace the loss of the old one. (Courtesy of the New Egypt Historical Society.)

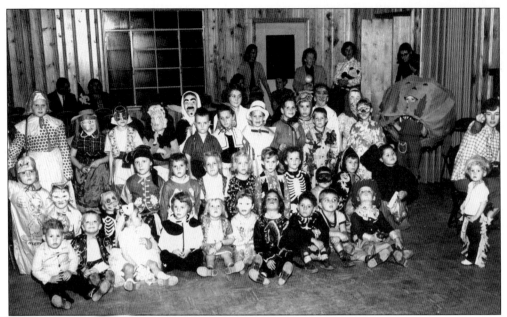

The Presbyterian church made many improvements throughout the years. In 1953 through 1954, they expanded along the back of the building. The extra room allowed for Sunday school parties such as this Halloween party in October 1955, when Kirk Hudson was pastor. Included in the photograph are Callie Hudson, Lynn Hudson, Betty Tantum, Don Lear, Joy Ingalls, and Paul and Edward Tantum. (Courtesy of Carolyn Lear.)

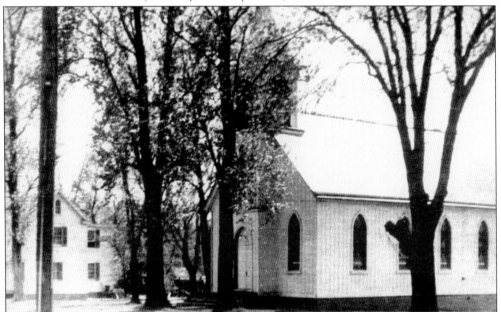

The Catholic church building was originally used by the Mormons in Hornerstown. Father Mackin of Bordentown first came there to offer mass at the home of Patrick Quinn. Finding the home too small for the following, he arranged for the church to be purchased. Eventually, the church was moved to its present location and blessed by Bishop Corrigan in 1874 under the name of Church of the Assumption. (Courtesy of the New Egypt Historical Society.)

Seven
SPORTS AND RECREATION

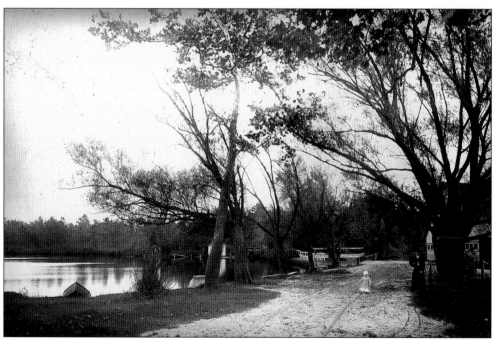

This scene of Brindletown at the beginning of the 20th century is reminiscent of the peaceful Sundays and Mondays when the lake was reserved for resident use only. Families and guests from the New Egypt hotels would come out to the lake for picnics, boating, bathing, and dances, but only from Tuesday through Saturday. Brindletown was purchased by the federal government to expand Camp Dix in the 1920s. It was later closed to the public. (Courtesy of the New Egypt Historical Society.)

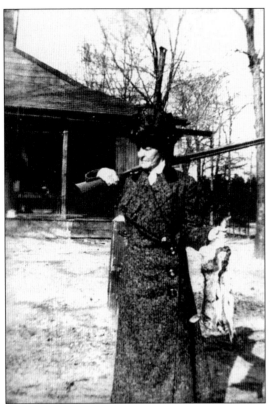

John G. Hutchinson owned all 1,000 acres of Brindletown, a third of this being Brindle Lake. Less than a dozen families lived here. The area was rich with cranberries and blueberries. The area was also well-stocked with game and fish. A resident of Brindletown has taken advantage of the plentiful game and is showing a nice brace of rabbits for the stew pot in the early 1900s. (Courtesy of the New Egypt Historical Society.)

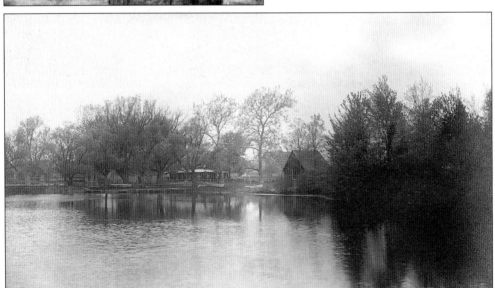

At Brindletown in the 1890s, the area's star fiddler, Ellis Parker, with his sidekicks, Joe Raymond on the harp and Jake Walker on the banjo, made music that people came from great distances to hear and dance lakeside. Parker also became the famous Burlington County detective who solved 288 major crime cases out of 300. Later, he made a major mistake on the Lindbergh kidnapping case that cost him his career and a jail sentence. (Courtesy of the New Egypt Historical Society.)

The name of Collier's Mills derives from the prosperous charcoal burners of the 1800s called "colliers." At that time, the area was busy with sawmills and smelters' furnaces. Ephraim P. Emson was a very prominent resident, owning more than 15,000 acres. His passion was for racehorses. He built two racetracks and kept a stable of 40 horses. Ironically, he was thrown from a spirited horse, resulting in his death. The village began a decline shortly thereafter. (Courtesy of the New Egypt Historical Society.)

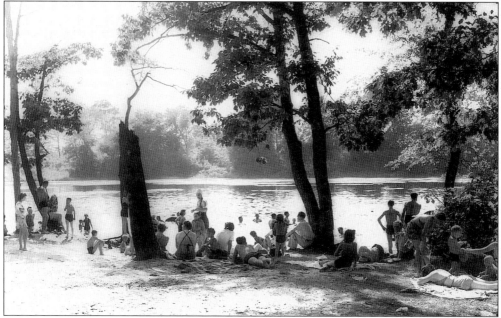

Collier's Mills is a typical pine-barrens area, full of pitch pine, scrub oak, and white cedar. In the 1900s, it became a destination for swimming, fishing, and boating in the summertime. In the autumn and winter, hunting is popular. Hiking is a favorite any time of the year for the many people watching for birds or looking for the many butterfly bogs. It is still a beautiful place for artists painting the landscape or wildlife. (Courtesy of the New Egypt Historical Society.)

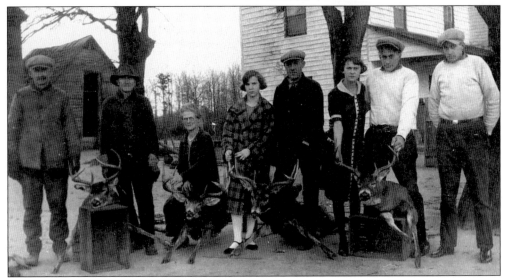

Hunting has always been part of the heritage in the New Egypt–Plumsted area. Shown here on the Hopkins Farm in the mid-1920s after a good brisk day at hunting are, from left to right, Tom Rossell, Dayton Hopkins, Carrie Hopkins, Margaret Hopkins, ? Cummings, Mary Hopkins, Sam Rossell, and Norman Rossell. (Courtesy of Carolyn Lear.)

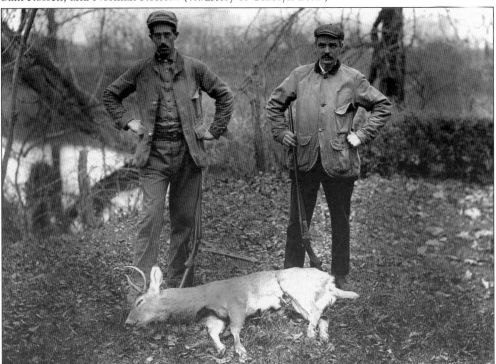

Harvey N. Moore has taken a day off from the hardware business that he bought from Francis R. Hope. He was born in Delaware but has returned to the roots of an old New Egypt family. He made improvements in the business, increasing stock from hardware to horse blankets and other farmers' supplies. He seems to have increased his home supplies too by adding one more deer to the larder while his unidentified partner looks on. (Courtesy of Bill and Karen Kisner.)

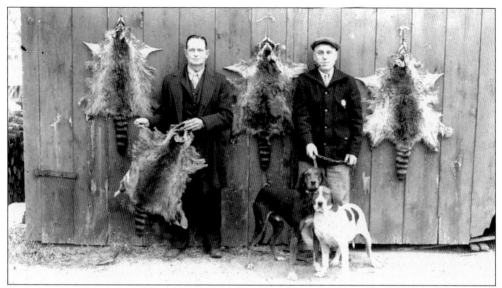

Showing us a different kind of hunting is William Feaster, holding two well-trained hounds firmly. He and his unidentified partner seem to have quite a nice display of raccoon furs to show for their effort. Dogs have to be run all year long to keep them in shape until hunting season arrives. (Courtesy of the New Egypt Historical Society.)

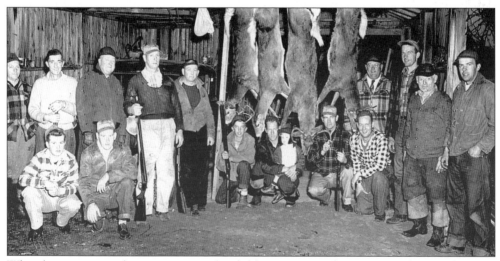

When hunting is a tradition in an area, the children are exposed to it at an early age. There is a wide range of ages in this hunt club photograph. When the New Egypt Fire Company had fundraisers for new equipment, the raffle for hunting weapons always brought in more profit than the dinners did. The hunt club is one of the reasons why. (Courtesy of the New Egypt Press.)

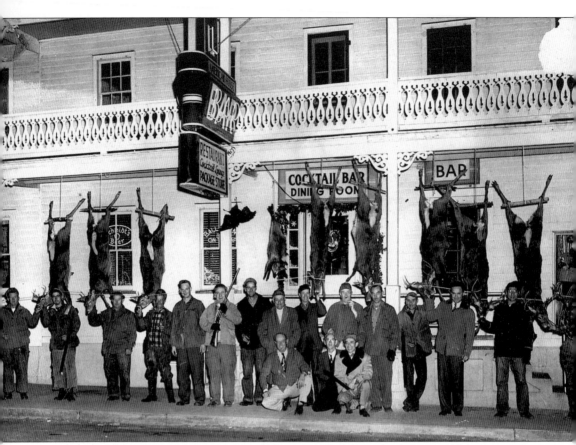

Hunting clubs were an important part of life, especially where the forests and lakes are so fine and so numerous. There was always a large number of clubs up until recent years, when this area became too populated. This is the American House Hunt Club in 1953 with a load of deer. A sole fox and bird are proudly displayed too. Shown, from left to right, are the following: (kneeling) Woody Reynolds, Old Don Crammer, and Jim Garafalo; (standing) Robert Southard, unidentified, Jew Archer, Walter Miller, Charles Pullen, Young Don Crammer, Pete Reynolds, Joe Malloy, Stead Bishop, unidentified, Doc Wharton, John Inman, Frankie Green, and Charles Horner. (Courtesy of the New Egypt Historical Society.)

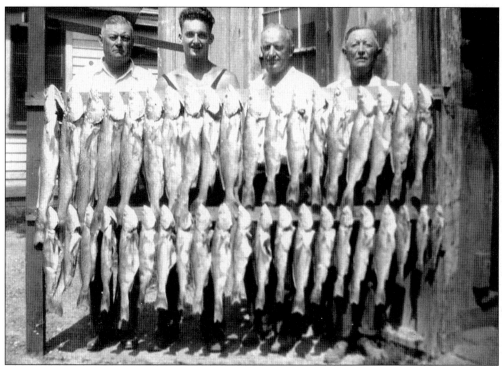

A beautiful catch of weakfish is shown with some happy fishermen in 1932 behind the old American House. From left to right are Art Letts, owner of the American House; Emerson Miller; his father, Max Miller; and Harry Irons. Fishermen tend to be happy with so many lakes in the area. (Courtesy of the New Egypt Historical Society.)

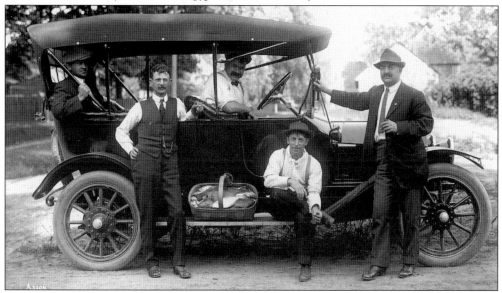

These unidentified men do not look like fishermen. They certainly are not dressed like they have been fishing, but that is a basket of fish on the running board of the car. They are on Railroad Avenue and are probably tourists down for a stay in the country. (Courtesy of Bill and Karen Kisner.)

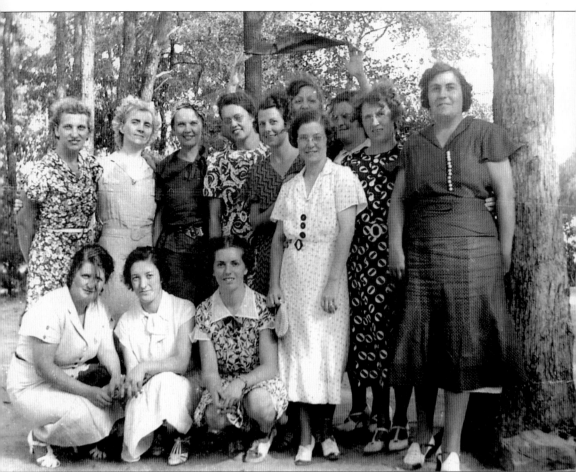

Sometimes, clubs are formed just for social recreation. The Here and There Card Club was such a union. In 1925, the group organized at the home of Myrtle Harker. Pictured, from left to right, are the following: (front row) Miriam Horner, Louise Moore, and Dorothy Turner; (back row) Irene Thompson, Hanna Foy, Doris Borden, Thelma Atkinson, Clara Burgin, Reba Compton, Carrie Van Horn, and Amalia Buckalew. The two women in the back are Irene Ryan (left) and Eva Tantum. Each week, one would host an evening of playing "Five Hundred Bridge" cards. They kept track of who was having a birthday, getting married, having a party, having babies, or celebrating an anniversary. Irene Ryan held the celebration for the 40th anniversary of the club with a covered dish supper on the lawn in 1965. Of course, they played cards. (Courtesy of George Compton.)

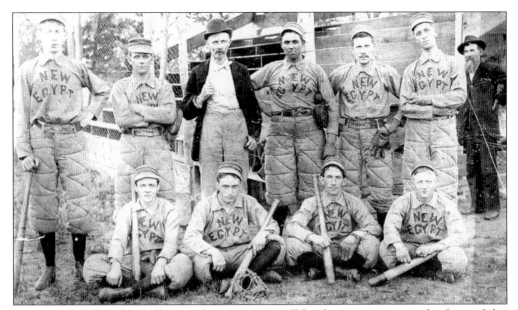

New Egypt took its baseball seriously, as you can tell by the expressions on the faces of this team. The year is 1899, and already baseball is an important part of the summer tourist season. They were called the Cornhuskers and played a great game. When the last game of the year was over, it was celebrated with a dance and orchestra at Harker's Grove. (Courtesy of the New Egypt Historical Society.)

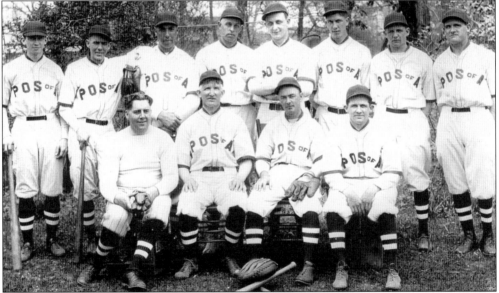

The Patriotic Order Sons of America sponsored this New Egypt baseball team in 1928. Pictured, from left to right, are the following: (front row) "Pickles" Clift (coach), Edward Errickson (manager), Russell "Runt" Irons (outfielder), and Marvin Errickson (pitcher); (back row) Claude "Dick" Thompson (outfielder), Roy "Righty" Johnson (outfielder), Fenimore "Pete" Emley (pitcher), Russell "Tickey'" Hopkins (baseman), Carroll Johnson (outfielder), Pierlin "Penny" Errickson (baseman), and Orval "Shorty" Errickson (short stop). (Courtesy of Margaret Errickson.)

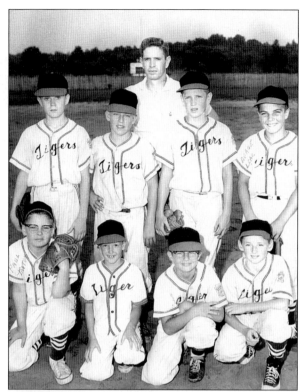

New Egypt–Plumsted Township has always loved sports and especially baseball ever since the game was first organized. Fortunately, there have always been good, interested volunteer coaches available. This 1959 photograph of the Little League Tigers shows, from left to right, the following: (front row) Paul Tantum, Glenn Moore, Bobby Blum, and Vernon Buckalew; (back row) unidentified, Jimmy Buckalew, Neil Moore, and Duane Lear. The coach is Walt Moore. (Courtesy of Carolyn Lear.)

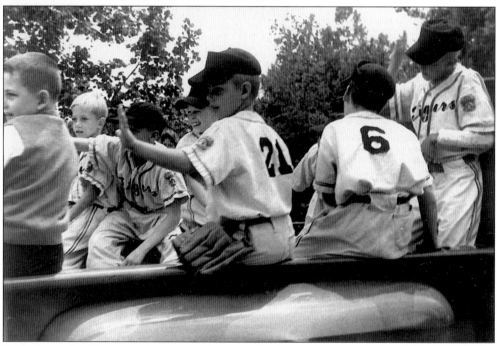

Sometimes, the Tigers got lucky enough to ride in the back of a pickup truck and go for ice cream. Baseball and ice cream are all-American pastimes. The players are unidentified. (Courtesy of the New Egypt Press.)

Racing has always been a favorite pastime in Plumsted, beginning in the early history with horses and later expanding to stock cars. What began in 1950 as the Fort Dix Races evolved into the New Egypt Speedway. Races were held every Sunday afternoon at two. Bob Goff remembers when he and Ronnie Letts whitewashed all the guardrails before the track opened for the season. On Memorial Day 1951, more than 1,000 cars were parked at the speedway. The American Legion post and the auxiliary held a memorial service on the infield with Commander Dunfee opening the ceremony. Auxiliary president Elsie Flach spoke about Poppy Day. Chaplain Francis gave the opening prayer. Marion Myroncuk's car, filled with auxiliary members, led the parade. Lela Brown distributed poppies. Poppy sales have helped veterans and their families since the tradition began. (Courtesy of the New Egypt Press.)

Anthony Horner is on top of his Chevy after it rolled at the New Egypt Speedway c. 1952. That could be a special dance celebrating that the car was not demolished, or it could be a touch of disappointment coming out. Horner married the Irish-born Honoria, affectionately known as "Sis." He wisely named his car the No. 522, which happens to be their wedding date. Tom Van Ardsdale also drove for him. All three of the Horner sons—Tony, Ward, and Phil Horner—followed their father in his passion for stock car races. All three spent a lot of time and effort in building and successfully driving racecars. Two other early stock car drivers at the New Egypt Speedway were Howard "Stubby" Stevens from Jacobstown Road and Howard "Brother" Goff from Cream Ridge. (Courtesy of Phil and Jean Horner.)

Charlie Hawkins (left) and Lane Marshall stand in front of Walt Watznauer's New Egypt Auto Body on North Main Street. The fins of a beautiful Chevrolet are showing in the bay. Back in 1932, this was the Tantum garage. At that time, there was a second floor that housed a shirt factory. (Courtesy of the New Egypt Press.)

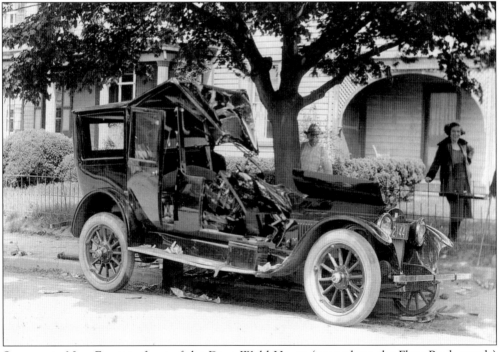

Summer in New Egypt in front of the Dave Wald House (now where the Fleet Bank stands) shows this once beautiful 1922 Essex that looks like it took a wrong turn. By the smiles of the onlookers, it appears no one was hurt. It might have been a job for the Tantum garage. (Courtesy of the New Egypt Historical Society.)

From the love of horses, coaches, and wagons in New Egypt came the love of cars, trucks, and anything with wheels. With that came pride in how your particular possession looked. Lakewood Road Auto Body was a popular stop for having your car, truck, and even racing helmets custom painted. The fire company did a fine job of putting the fire out before too much damage was done. Owner Bill Brady was back in business in no time. (Author's collection.)

Good things often come from bad. After the fire damage was cleaned up at Lakewood Road Auto Body, owner Bill Brady built this purple customized Harley-Davidson motorcycle. He entered it in the National Show at Asbury Park, competing against bikes from all over the country, including California. He took home the second-place trophy the first time he entered and won a first place the next year. (Author's collection.)

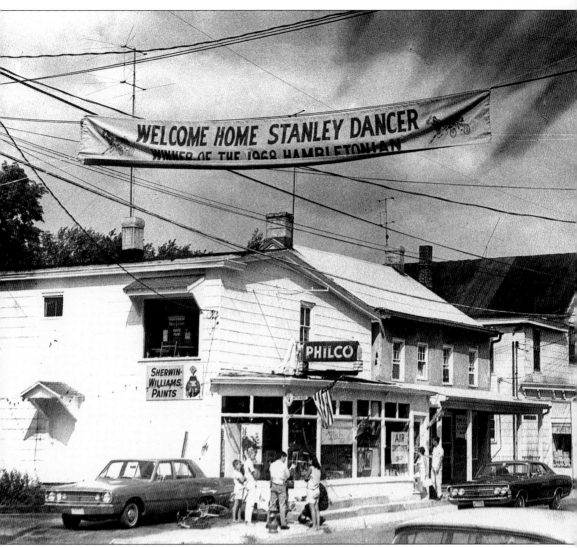

The people outside Wright's Hardware are probably talking about how the town is proud of its famous son, Stanley Dancer. He had just won the 1968 Hambletonian, driving Nevele Pride over the finish line. Nevele Pride was the only trotter to be voted Horse of the Year for three straight years. This win for Stanley Dancer was 15 years after his first race in the Hambletonian. He went on to win three more Hambletonians. Dancer is also the only driver to win two triple crowns. The stallion, Hambletonian 10, dubbed "the Great Father," was foaled in 1849. He never raced but was leading speed sire for many years. Ninety-nine percent of both trotters and pacers of North America can trace their pedigree to him. (Courtesy of the New Egypt Press.)

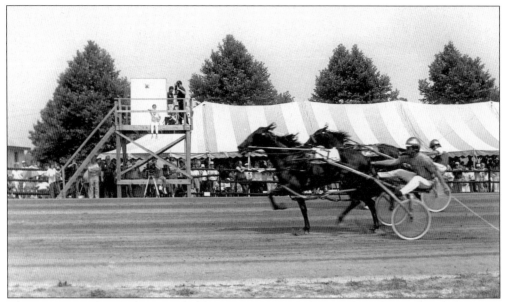

The New Jersey Sire Stakes were held at Egyptian Acres, home of Stanley and Rachel Dancer for a number of years. The purpose of the Sire Stakes is to promote competition for New Jersey Standardbreds, for improvement and economic incentives. This is especially important to smaller, nonsyndicated training and breeding horse farms. The excitement of the racing sport just leaps off this photograph. (Courtesy of the New Egypt Press.)

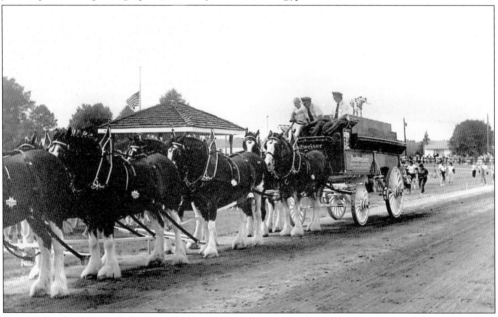

Part of the festivities at the Sire Stakes at Egyptian Acres is Clydesdale horses doing what they do best: pulling heavy loads. Here, the team waits patiently, which they are known for, along with their white, long-haired lower legs. Clydesdales stand 16 to 17 hands high. They originally came from the Clyde Valley, Lanarkshire, Scotland. Foods were provided by the New Egypt Elks Lodge No. 2457. Volunteers flipped burgers and burned hot dogs as a fundraiser for the lodge. (Courtesy of the New Egypt Press.)

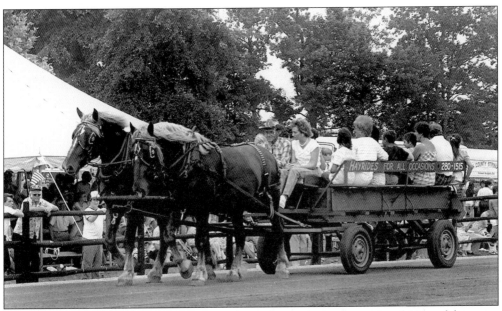

There were a lot of things to do at Egyptian Acres during the racing weekend. One of them was taking a wagon ride with Clarence E. Halpin at the reins. The horses are definitely different than the Standardbreds on the track, but these people do not seem to mind. The affair drew large crowds of people, and the weather cooperated beautifully. Egyptian Acres is reputed to have been a swamp at one time. (Courtesy of the New Egypt Press.)

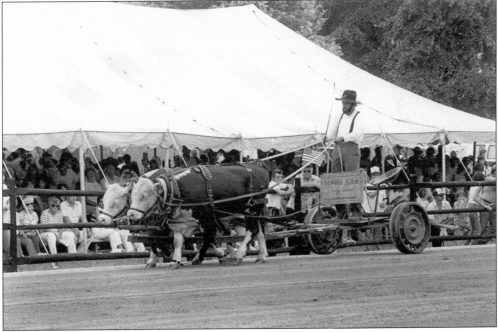

These are definitely not horses pulling this piece of antique farm equipment. This is Pete Watson, administrator from the Howell Living History Farm, here to educate everyone at the Sire Stakes on the history of farming. Inez Howell left the farm, dating back to 1732, to Mercer County so youth could learn about the history of farming.

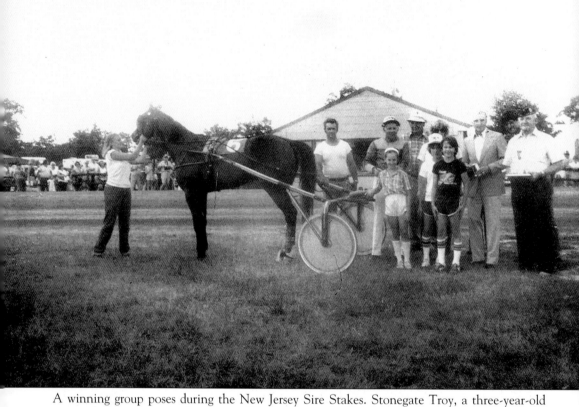

A winning group poses during the New Jersey Sire Stakes. Stonegate Troy, a three-year-old trotter, has just won the fourth race. He was driven by Stanley Dancer (in racing silks). The unidentified people around him are certainly the owners and family. Dancer comes from a racing family. Harold, Papa Jim, Vernon, and Stanley are affectionately known as "the First Family of Harness Racing." Stanley went on to set records and become the first name in harness racing. (Courtesy of the New Egypt Press.)

Eight
PARADES

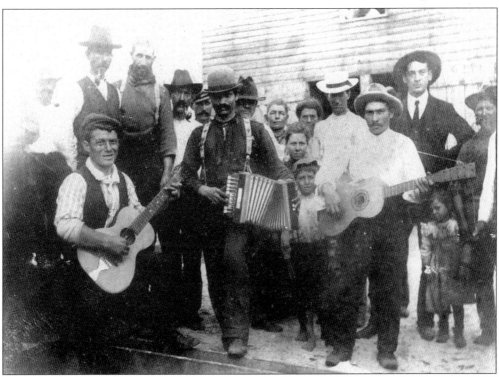

The New Egypt Cornet Band was formed in 1922. Charles Warwick was the instructor, and William Nutt was the manager. On cornets were Marvin Errickson, Vernon Nutt, Jacob Fischer Jr., and Rush Warwick; the altos were Orval Errickson and Floyd Hopkins; on bass was Norman Irons; the tenor was Aaron Himmelstine; the baritone was William Nutt; on kettle drum was Kenneth Compton; and on bass drum was Samuel Pullen Jr. They were popular and played all over the area. (Courtesy of the New Egypt Historic Society.)

Young Joe Davis has his horse all decorated for the Fourth of July parade in 1910. The parades of this era were fancy and elaborate. His father was Howard L. Davis, famous poultryman. He is a life member of the American Poultry Association and a charter member of the Order of the Flea. (Courtesy of the New Egypt Historical Society.)

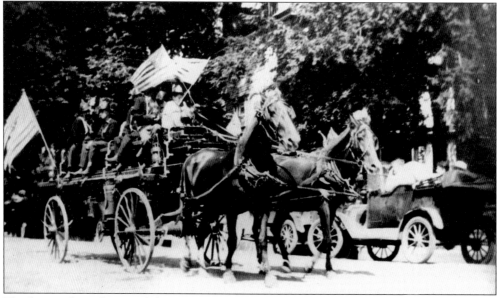

The firemen have decorated the wagon up for the Fourth of July in the same early-1900s parade. In 1904, a firecracker started a fire on the roof of the post office. It was a good thing the firemen were in the parade to put the fire out. In these early days, when the alarm rang, whoever brought their team of horses first to pull the fire truck received $1 for his efforts. (Courtesy of the New Egypt Historical Society.)

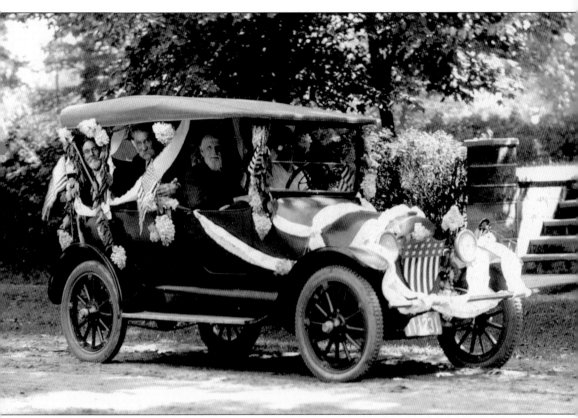

Everyone loves a parade and especially in New Egypt. This particular Fourth of July parade in the early 1900s held special honor for the Civil War veterans. Bossy Dunfee looks out of the passenger-side front seat at everyone looking at him. The others are unidentified but seem to be enjoying all the attention. Dunfee was wounded in his hip while serving with the 10th Regiment, New Jersey Volunteers, Company G in the Civil War. After returning home, he married Rebecca Vaughn in 1865. He was an avid hunter and fisherman, as were many men and some women in the Plumsted Township area. Well known for his tannery, he also seemed to have a flamboyant attitude toward life. Bossy was also the operator of Horse Heaven, hauling off the carcasses of horses and other large animals on the Riley-Allen estate in New Egypt.

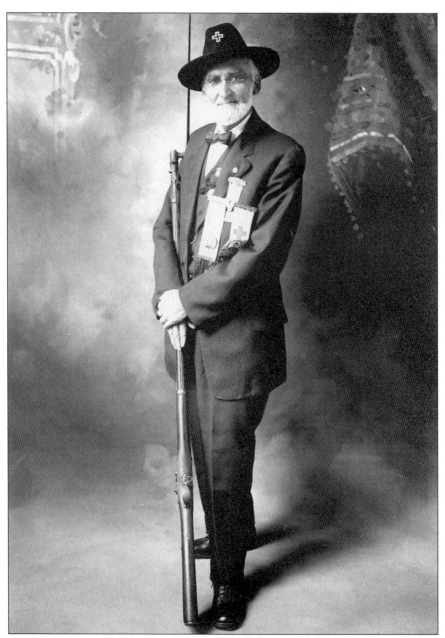

When Henry H. Hankins was 20 years old, he left the farm to enlist with the 14th Regiment, New Jersey Volunteers, Company F. He fought in 27 battles and was wounded in three different places. He was taken prisoner at the Battle of Monocacy, Frederick, Maryland, in July 1864. The Confederates transported him to Richmond, where he spent seven months and 21 days in Libby Prison. He weighed 150 pounds when he went into the prison and 82 pounds when he came home. Starting in 1866, he became a very successful house and bridge builder. In the winter months, when the weather discontinued his work, he was a professional hog slayer. He soon built a reputation as the fastest hog killer, completely dressing three hogs a minute. Hankins enjoyed a high personal standing in the community throughout his lifetime. (Courtesy of Bill and Karen Kisner.)

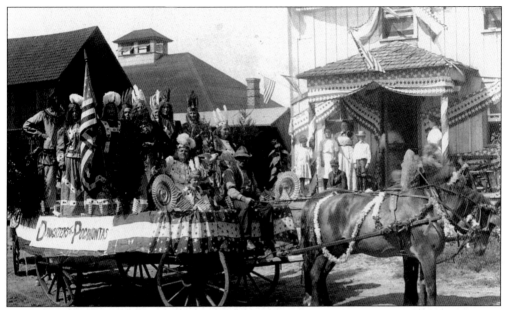

On this parade wagon driven by Mickey Murphy are members of the Daughters of Pocahontas. The Degree of Pocahontas is the women's affiliate of the Improved Order of Red Men, organized in 1885. The name is derived from Pocahontas, the daughter of Powhatan, Algonquian Indian chief. (Courtesy of the New Egypt Historical Society.)

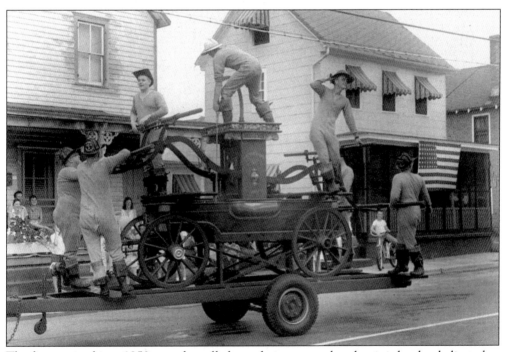

The firemen in this c. 1950s parade really have their act together, but it is hard to believe that pumper actually put fires out. It did in the old days. The firemen are unidentified, probably because they do not want to be caught in their skivvies. (Courtesy of the New Egypt Press.)

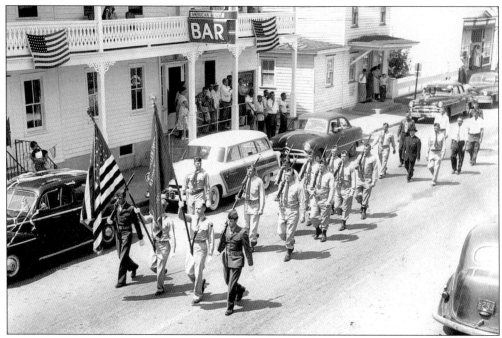

A group has gathered outside the American House bar to view a parade in the early 1950s, when the building to the right of the American House was still standing. The American flags show 48 stars. Veterans always lend a sense of pride and seriousness to a parade. (Courtesy of Bill and Karen Kisner.)

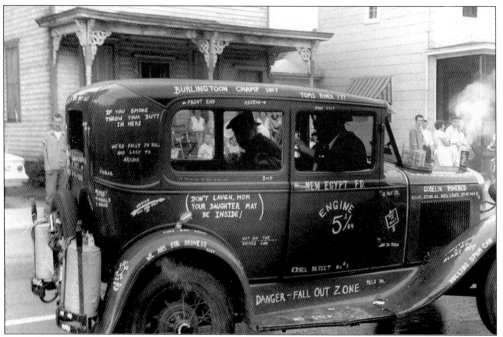

Now *here* is a man who does not know which way he is going. Jimmy Moschera built this car going the other way. (Courtesy of the New Egypt Press.)

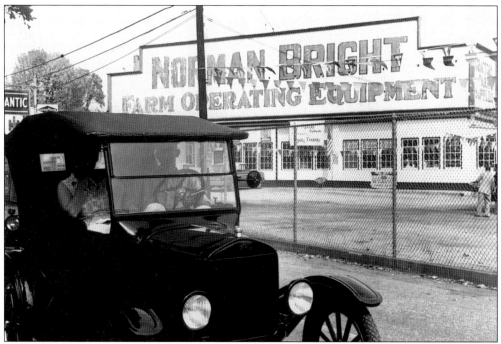

This photograph shows a mix of the new and the old. The old Model T is being driven into the parade by modern folks. The old Norman Bright farm equipment business, with a new coat of paint outside, had expanded into selling new modern home appliances and more. (Courtesy of the New Egypt Press.)

These boys are just hanging out and checking out that line of cars parked on the bridge. They are waiting for the parade to begin. The sign across the street reads, "Frozen Custard," and next to that is Gabby Johnson's Laundromat. (Courtesy of the New Egypt Press.)

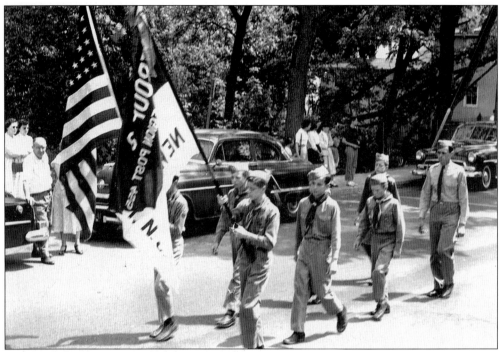

Here we see the Boy Scout Troop No. 9 marching in the 1957 Memorial Day parade. American Legion Post No. 455 was their sponsor. The Boy Scouts could always be counted on to add importance to a parade. (Courtesy of Bill and Karen Kisner.)

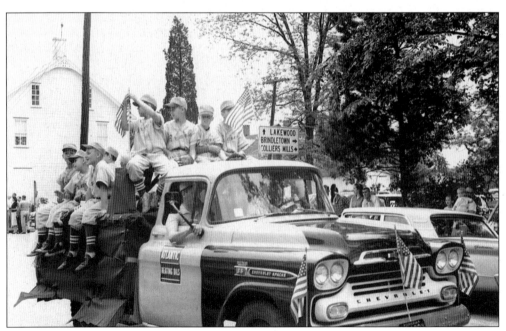

It looks like Atlantic Heating is chauffeuring a winning baseball team in this Memorial Day parade in 1960. The sign behind the truck will keep anyone from getting lost during the celebration remembering our veterans. (Courtesy of the New Egypt Press.)

Everyone loves a parade, but this boy is all ready to enjoy it to the most. He has his flag for waving, his shades to keep out the sun, and his pipe for biting onto. Without fans, parades would not be half as much fun. He looks like an offshoot of Bing Crosby. (Courtesy of the New Egypt Press.)

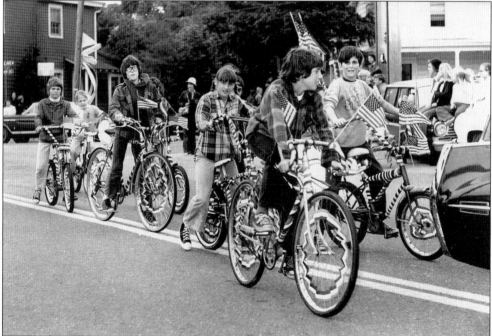

Children make all the fuss of a parade worth the time, energy, and work that people volunteer. The tradition of decorating your bicycle made watching or riding in the parade much more fun. (Courtesy of the New Egypt Press.)

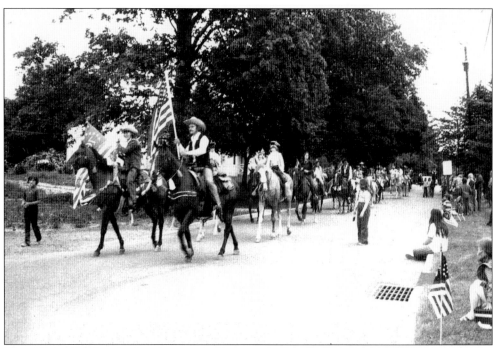

This is Larry Hopkins leading his troop of horse and riders through the parade, carrying the flag proudly as he does so often in New Egypt Memorial Day parades. He may look like an old-time sheriff here, but he became a modern-day chief of police. (Courtesy of the New Egypt Press.)

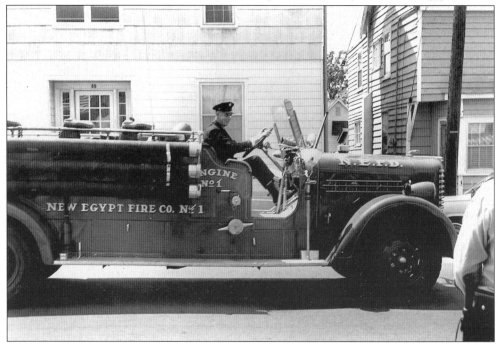

A parade would not be complete without the fire trucks. This is the New Egypt Fire Company No. 1 being represented. The pumper is a 1937 Pierce, and the parade is taking place in the early 1960s on Memorial Day. (Courtesy of the New Egypt Press.)

Nine
THE RAILROAD

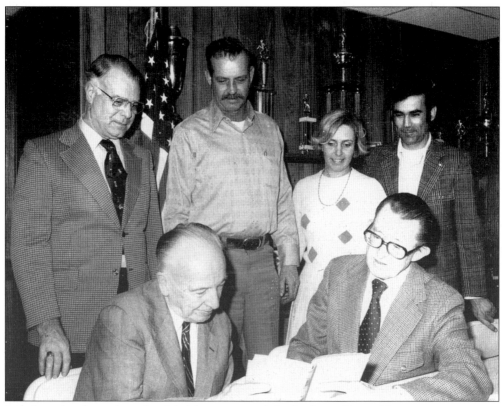

Jack Lamping (seated on the right) has presented the book on Ocean County government to the New Egypt Historical Society. Attorney Dayton Hopkins turns the pages while society onlookers read over their shoulders. The members are, from left to right, Owen Moore, James Griswold, Pat Gale, and Donald Reed. (Courtesy of the New Egypt Press.)

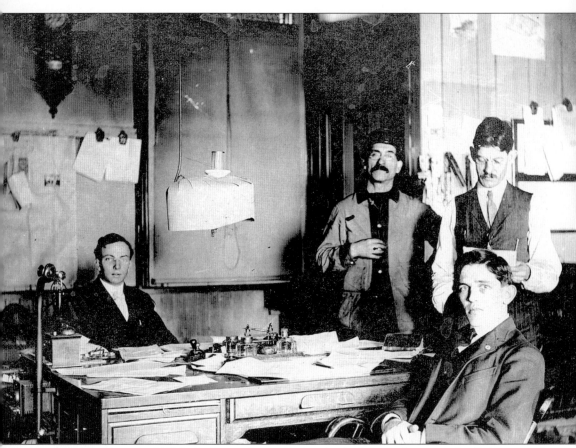

After the blizzard of 1888, the Pennsylvania Railroad, which had taken over the Delaware and Raritan Canal Company, stopped its rail service to New Egypt. The farmers who relied on getting their produce to market decided to form a cooperative; this became the Union Transportation Company. The photograph shows the interior of the Union Transportation office, located on Railroad Avenue (now Evergreen). They sold stock, obtained a lease for the rail lines, purchased two steam engines, and were in business. New Egypt was a main stop for the railroad. The turntable was here. The ringing of the bell and the hissing of the steam were a noisy welcome as happy vacationers were brought to the area. Clusters of people were anxiously waiting at the station to greet the newcomers. Mail, supplies, and packages were unloaded. The hustle and bustle created its own excitement. (Courtesy of Bill and Karen Kisner.)

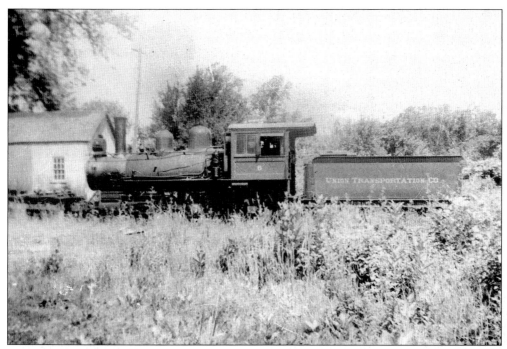

Coming from New Egypt, Union Transportation engine No. 6 was backing up to the siding when an axle broke. A wheel flew up in the air and just missed the cab. George Inman was the engineer. The Great Blizzard of March 1, 1914, had engine No. 6 snowed in for four days between New Egypt and Camp Dix. During the 1930s, the line was in service for six months and off for six months. (Courtesy of the New Egypt Historical Society.)

Old Model T cars were put to good use by the railroad. The Union Transportation Company hired Theodore Gaskill to convert the cars from roadway use to railroad use. Tools were kept right inside the car so the maintenance men were always ready to repair the track immediately. This is a center-door car. (Courtesy of the New Egypt Historical Society.)

Pennsylvania Railroad No. 5244 is shown here loading up coal from Norman Bright's, probably in June 1958. On that day, the engineman was Elmer Jones, the brakemen Art Kemp and Frank Inman, the conductor Charles Faber, and the fireman Charlie Horner. No. 5244 was the last steam engine on the Pemberton-to-Hightstown run. Steam power had been in use on the rails in New Jersey since 1833. No. 5244's days were numbered regardless of the fact that it was in good condition. Diesel was coming. In 1959, it was sent to the 46th Street Enginehouse to await final dismantle, but the historic locomotive was to stay in the minds of railroad men. The bell was removed from the engine and continued to ring, calling the stockholders to order for their annual company gatherings. (Courtesy of the New Egypt Historical Society.)